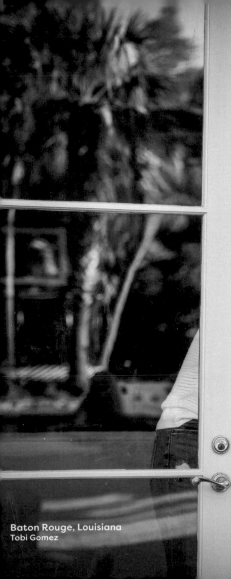
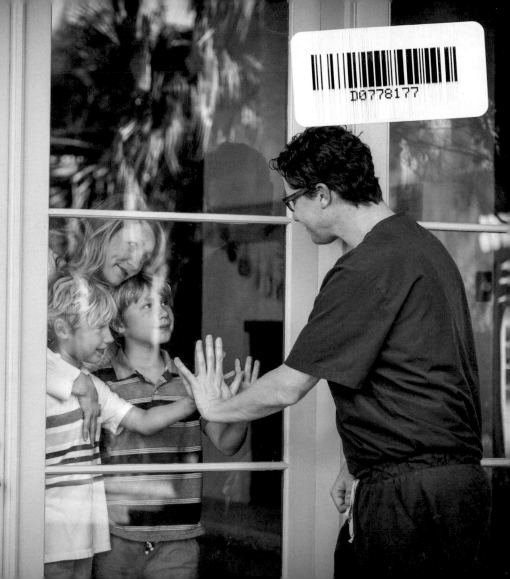

Baton Rouge, Louisiana
Tobi Gomez

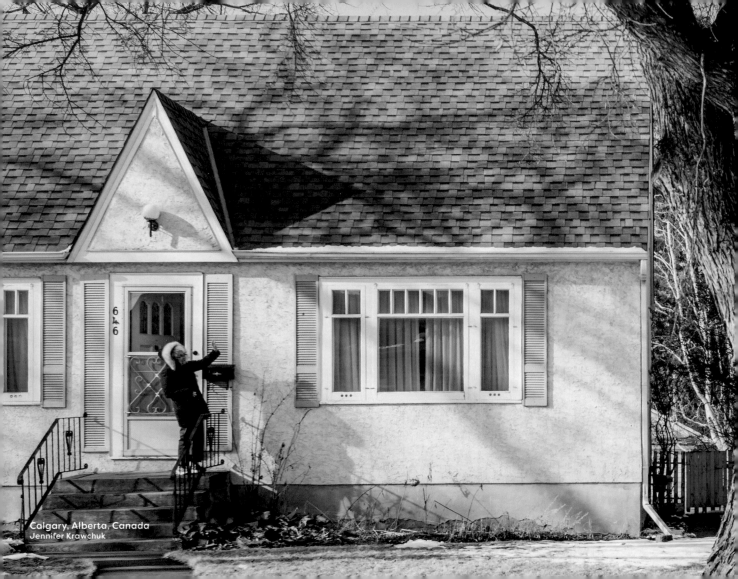

THE FRONT STEPS PROJECT

How Communities Found Connection During the COVID-19 Crisis

KRISTEN COLLINS and **CARA SOULIA**

WEST MARGIN PRESS

"We're so glad you're here!"

"So am I! How are you guys doing?"

These words, in any other context, seem basic. An everyday casual greeting, right? But in the spring and summer of 2020, they meant more. These words were exchanged hundreds of times among photographers and their neighbors as #TheFrontStepsProject, a grassroots social mission to connect communities through philanthropy, roared through cities and towns across the globe. These greetings provided a brief lifeline to normalcy.

Traveling through suburban neighborhoods, city streets, and rural towns, photographers participating in The Front Steps Project captured faces of people stepping outside for the first time in days. Most participants, thrilled to see a friendly face, were simply happy to have something to do! Even from ten feet away, these quick connections offered a jolt of positivity.

Through this endeavor, photographers captured the myriad ways people sought to feel normal in an isolating time. They documented anniversaries, birthdays, graduations, senior prom outfits, last days of chemotherapy,

pregnancy announcements, newborn joy, and more. And the costumes. Lots of hysterical costumes.

Participating photographers witnessed so many amazing moments: impish smirks on young faces; giggles after being tickled to elicit a smile; toddler meltdowns; chuckling parents; folks admitting they'd taken their first shower in days; decorations, especially rainbow art; and relieved smiles after a loved one returned home from a shift as a healthcare worker.

Scour the hundreds of images that The Front Steps Project produced (only a fraction of which are featured in this book) and you'll notice themes of **CONNECTION** and **UNITY** in the smiles. Take a closer look and you'll see the fundamental fabric of **COMMUNITY**—the ways people connect emotionally even during the most difficult times, and the ways people show **RESILIENCE**, even when separated. *The Front Steps Project* documents life in isolation and touches on many emotions in the human experience.

**LOVE • HOPE • KINDNESS • COURAGE • HUMOR • PLAY
JOY • COMPASSION • PRIDE • SACRIFICE • PERSEVERANCE**

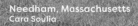
Needham, Massachusetts
Cara Soulia

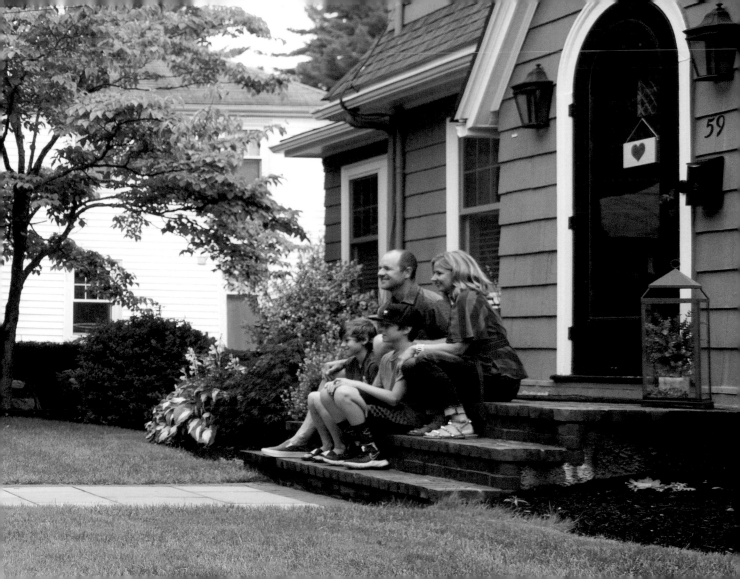

" We collaborate on ways to grow our businesses and juggle our ever-changing lives. **On March 12, our latest plans evaporated when our Boston suburb reported its first case of COVID-19.** Six days later, we launched #TheFrontStepsProject. Our intention was to keep busy, spread some smiles, and raise money for the Needham Community Council, our town's most impactful nonprofit. We posted the first image on March 18 and our inboxes overflowed with interest. Thanks to fellow creatives Topher Cox, Caitrin Dunphy, Kate King, and Lily Weitzman, **we connected with close to 800 families and raised over $50,000. But that was only the beginning...**

Cara Soulia and Kristen Collins, Needham, Massachusetts

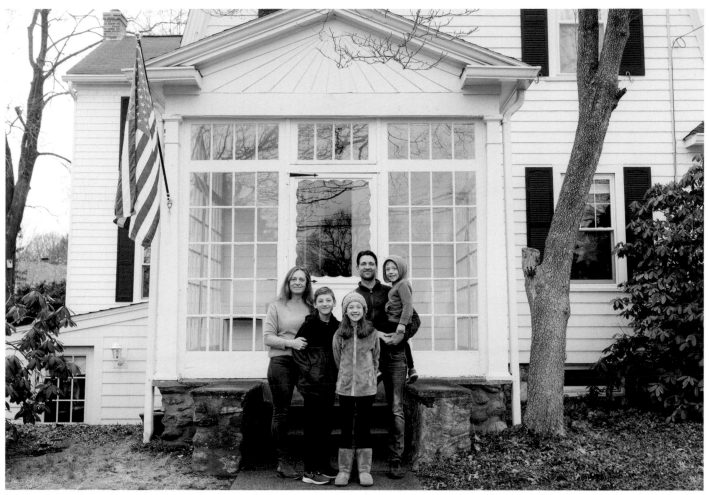

Needham, Massachusetts

Cara Soulia

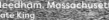
Needham, Massachusetts
Kate King

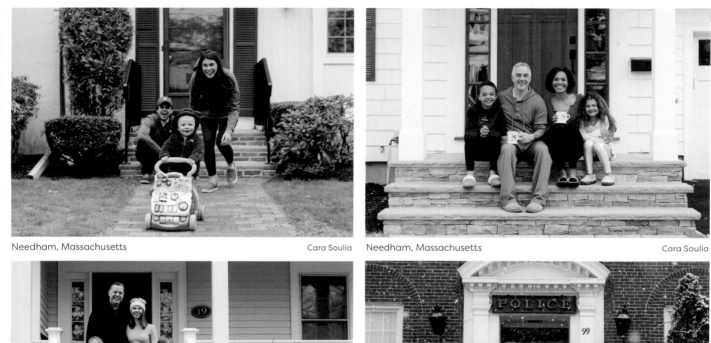

Needham, Massachusetts — Cara Soulia

Needham, Massachusetts — Cara Soulia

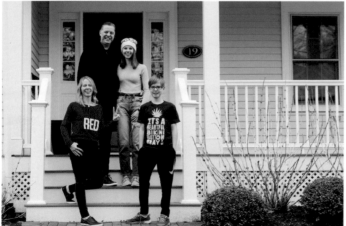

Needham, Massachusetts — Cara Soulia

Needham, Massachusetts — Caitrin Dunphy

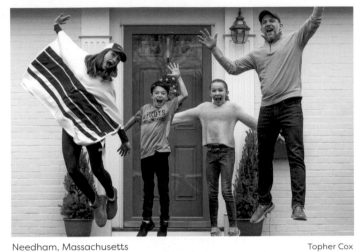

Needham, Massachusetts Topher Cox

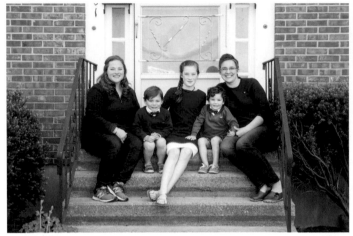

Needham, Massachusetts Caitrin Dunphy

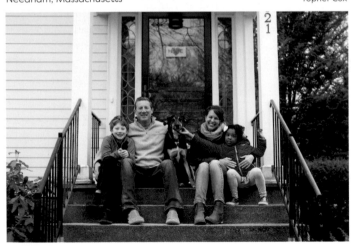

Needham, Massachusetts Caitrin Dunphy

Needham, Massachusetts Cara Soulia

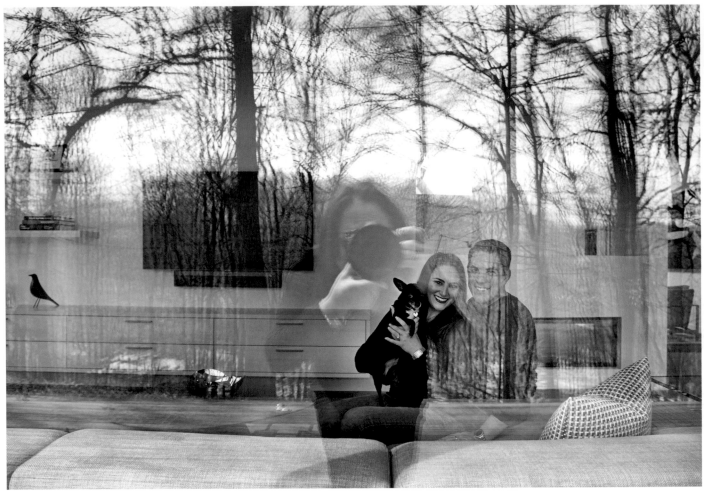

Minnetonka, Minnesota

" During the first week we juggled remote learning, spouses permanently at home, toilet paper shortages, and constant requests for Front Steps photos. Messages poured in from fellow photographers: "Can I do this, too?"

In the spirit of philanthropy, we shared our simple steps for creating a Front Steps Project. Within days, the hashtag multiplied on social media: New York, North Carolina, Tennessee, Colorado, California, Hawaii. Then Australia! New Zealand! Scotland! Hundreds of photographers from around the world voluntarily replicated our program, bringing thousands together despite being—and probably feeling—isolated themselves. We were unprepared, yet incredibly grateful, for the overwhelming response.

Cara Soulia and Kristen Collins, co-founders of The Front Steps Project

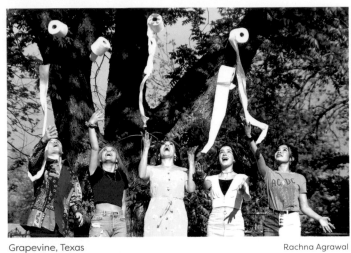

Grapevine, Texas Rachna Agrawal

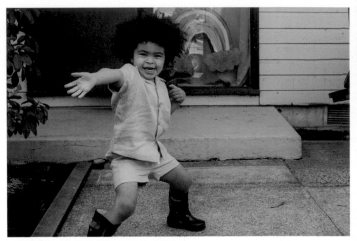

Vancouver, British Columbia, Canada Laura-Lee Gerwing

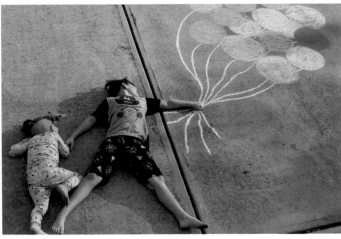

Santa Rosa Beach, Florida Sue Gambla

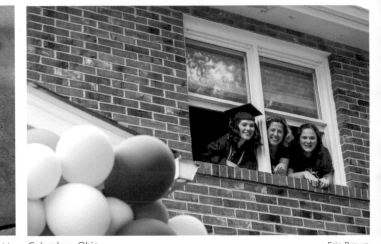

Columbus, Ohio Erin Brown

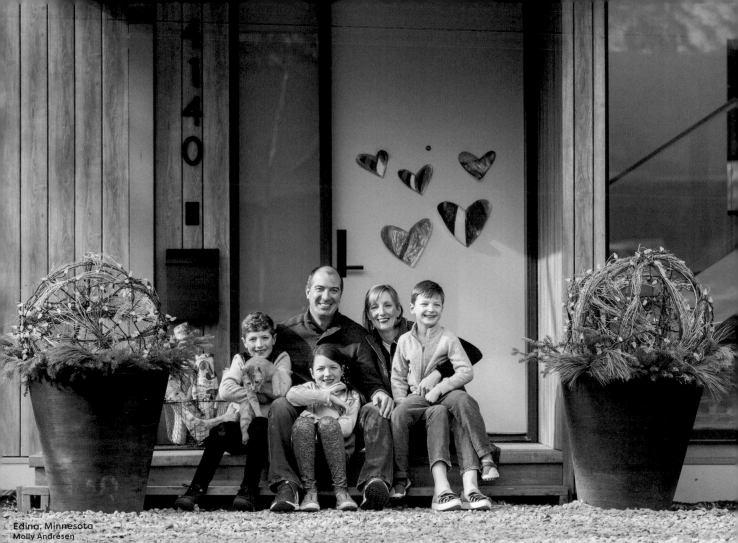

Edina, Minnesota
Molly Andresen

Vancouver, British Columbia, Canada
Laura-Lee Gerwing

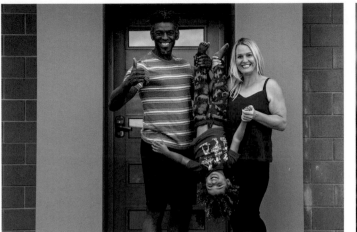

Tauranga, New Zealand

Kelly O'Hara

IT'S FINE,
WE'RE FINE,
EVERYTHING IS
FINE.
QUARANTINE
2020

Faxon, Oklahoma

Stacy Pearce

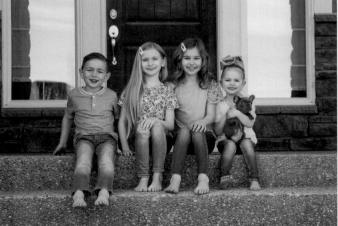

De Winton, Alberta, Canada

Anett Meszaros

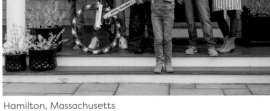

Hamilton, Massachusetts

Jen Maguire

"My takeaway from this experience
is that no matter how broken
the world may seem, humanity will
always find a way to love intentionally,
support unconditionally,
and overcome any obstacle that
stands in our way... these photos
tell us that **LOVE** lives here."

Abigail Blalock, Alexandria, Louisiana

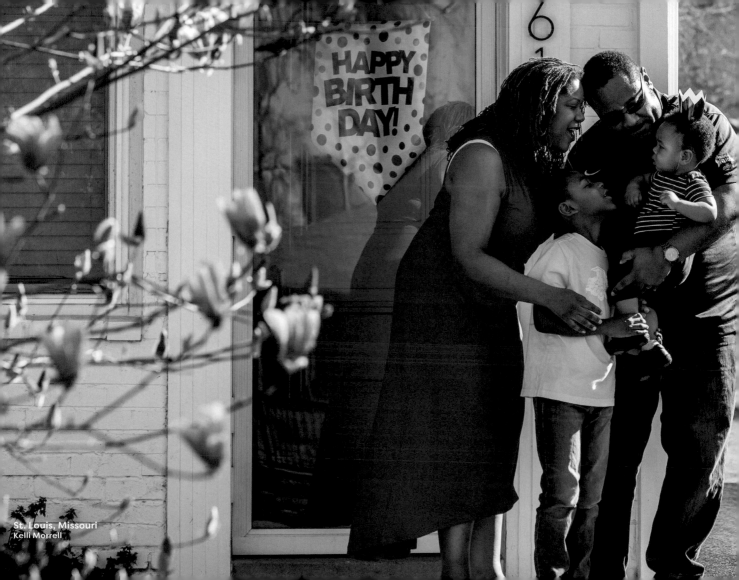

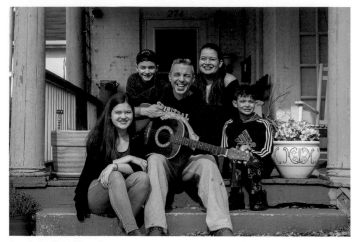

South Amboy, New Jersey Amy McLaughlin

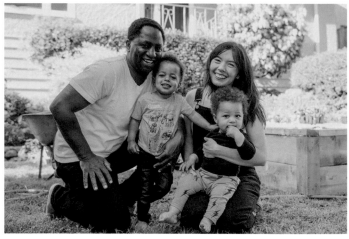

Somerville, Massachusetts Kristen Fuller

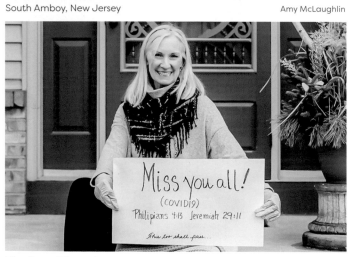

Miss you all!
(COVID19)
Philipians 4:13 Jeremiah 29:11

this too shall pass...

Woodbury, Minnesota Sigrid Dabelstein

Vancouver, British Columbia, Canada Eva Eariello

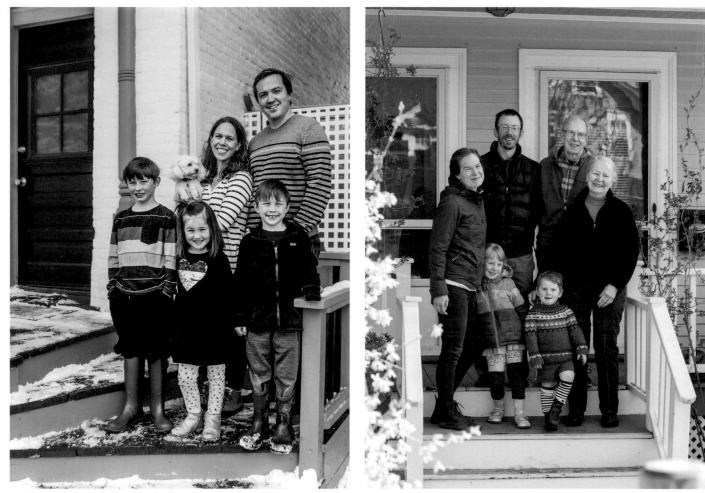

Butte, Montana

Hunter Blodgett

South Hamilton, Massachusetts

Tracey Westgate

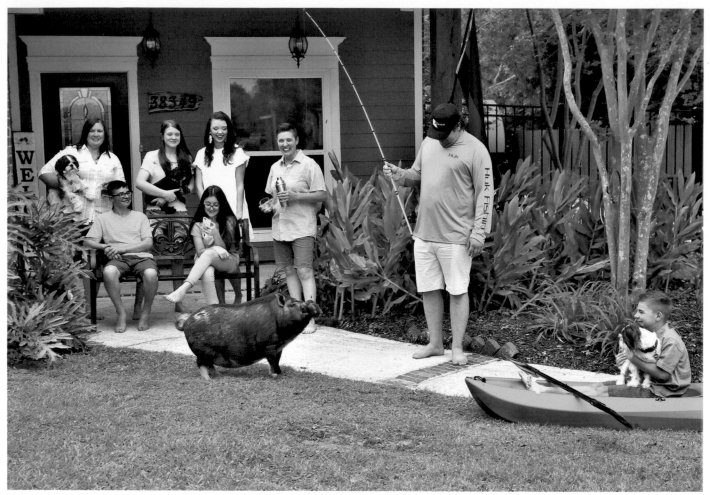

Gonzales, Louisiana

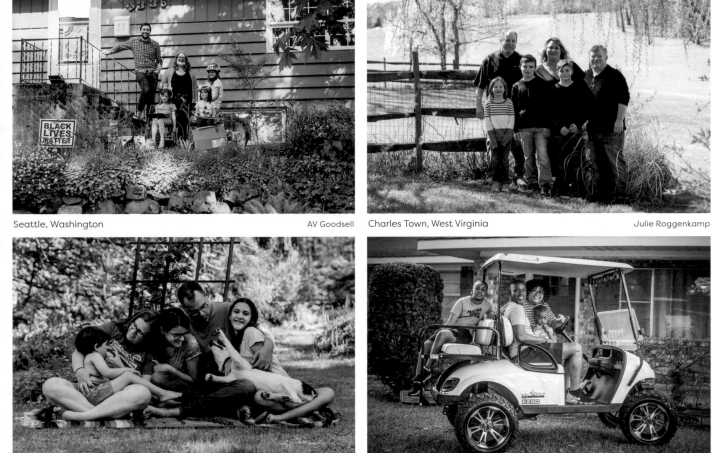

Seattle, Washington — AV Goodsell

Charles Town, West Virginia — Julie Roggenkamp

Amherst, Massachusetts — Isabella Dellolio

Alexandria, Louisiana — Abigail Blalock

" This image represents **eight families on the same block in Brooklyn.** Despite living yards from one another, it wasn't until lockdown that they really began to get know each other. **Hanging out on the stoops more often to cope with isolation, they discovered the joy of togetherness and created a close community.**

Shrutti Garg, Brooklyn, New York

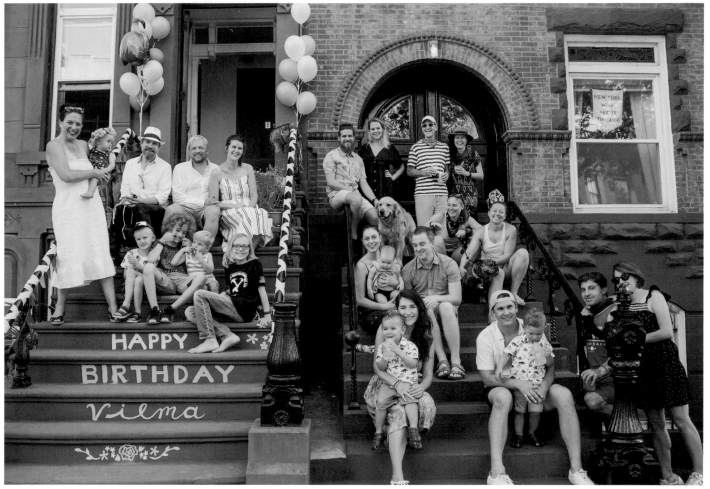

Brooklyn, New York

Shrutti Garg

Sydney, Australia — Marie Berroa

Stafford, Virginia — Megan Hubbard

Manitoba, Winnipeg, Canada — Kristen Sawatzky

Rancho Palos Verdes, California — Ute Reckhorn

Boise, Idaho Taylor Badzic

Needham, Massachusetts Topher Cox

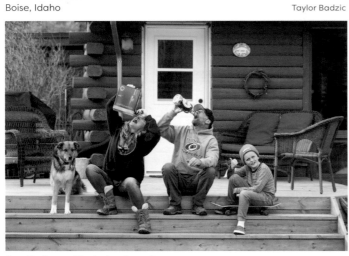

East Braintree, Manitoba, Canada Bree-Ann Merritt

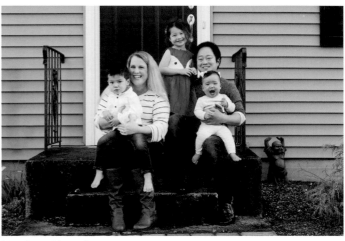

Needham, Massachusetts Cara Soulia

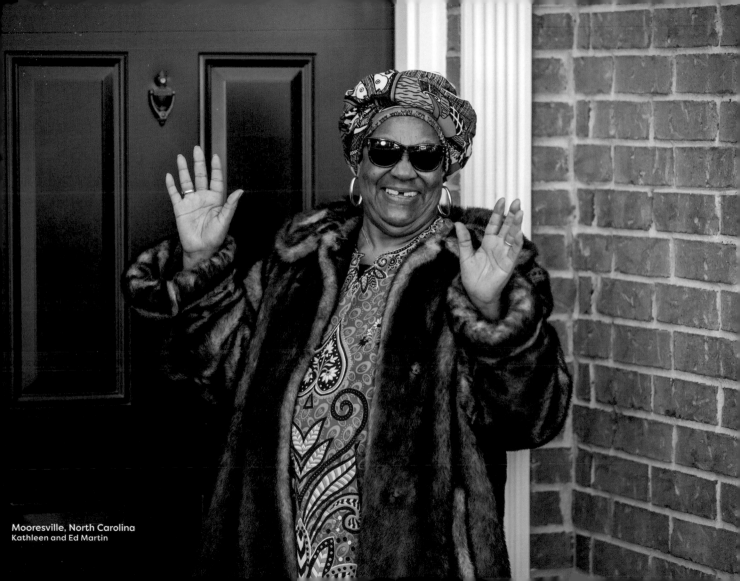

Mooresville, North Carolina
Kathleen and Ed Martin

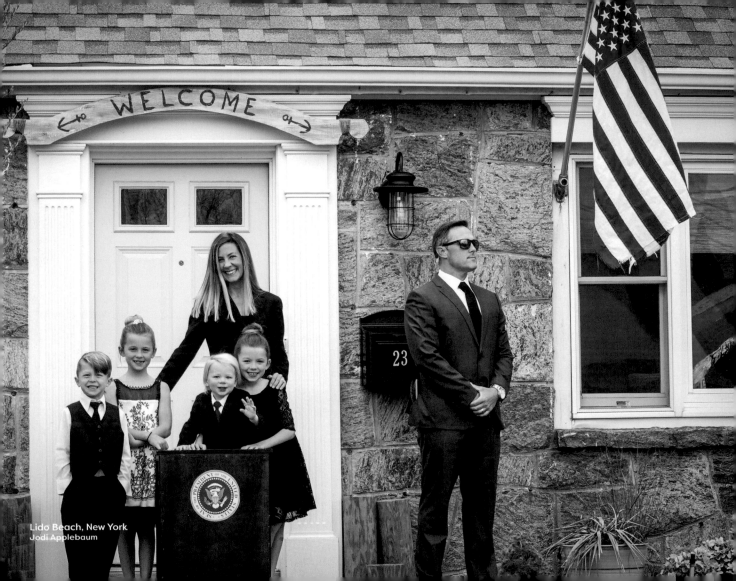

Lido Beach, New York
Jodi Applebaum

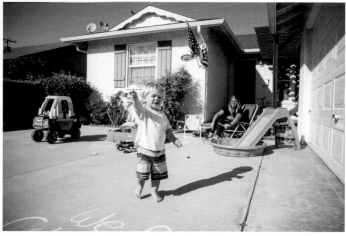

Torrance, California Ute Reckhorn

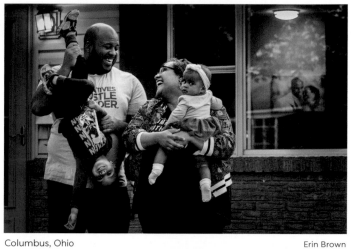

Columbus, Ohio Erin Brown

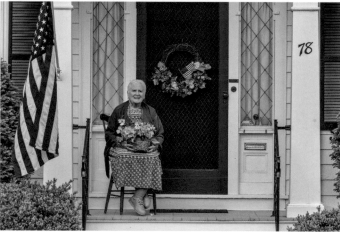

Needham, Massachusetts Cara Soulia West Hartford, Connecticut Andrew Stabnick

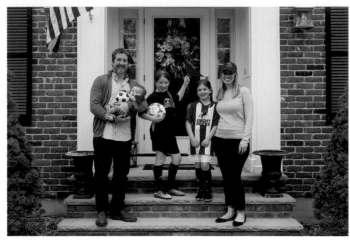

North Andover, Massachusetts

Jenn Freson

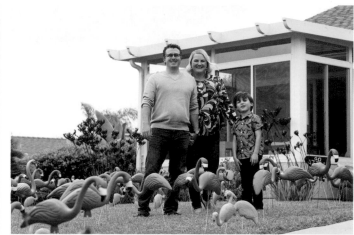

Carlsbad, California

Melissa Au

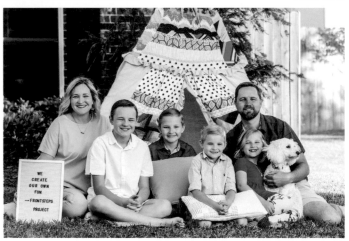

Pearland, Texas

Amy Nathans

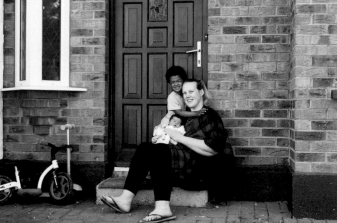

Dublin, Ireland

Maria Rusk

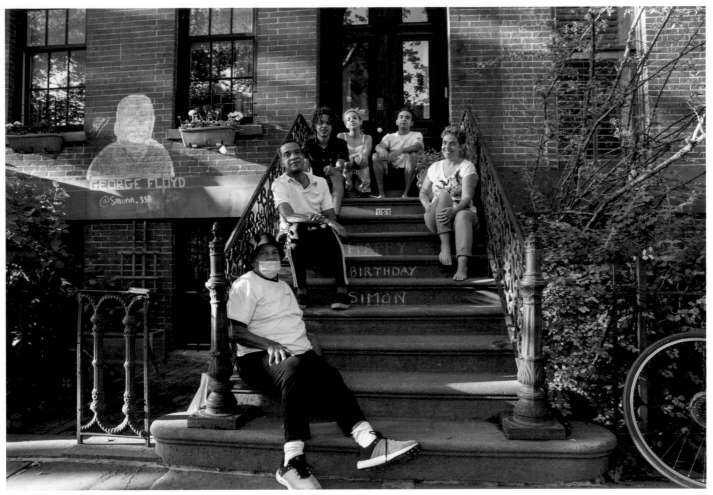

Brooklyn, New York

Marj Kleinman

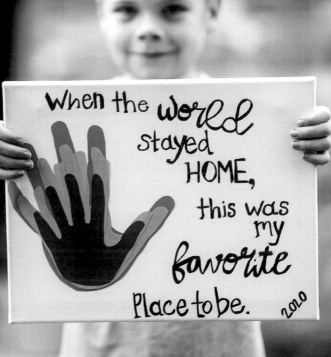

When the world stayed HOME, this was my favorite place to be. 2020

Long Beach, Mississippi
Jessica Holland

"In times of crisis, everyone looks for a beacon of **HOPE**. While photographs may not be the vaccine for COVID-19, The Front Steps Project brought light to my community. It brought a sense of making an impact and it gave everyone something to look forward to."

Stephanie Brand, Alameda, California

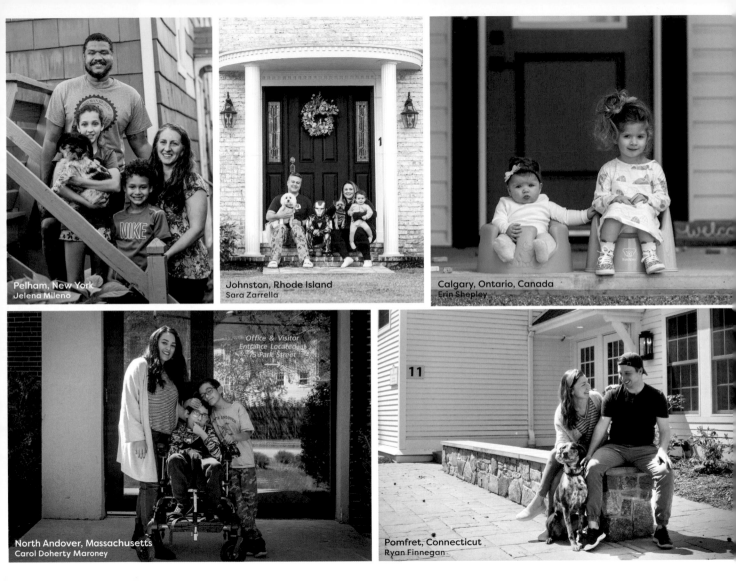

Pelham, New York
Jelena Mileno

Johnston, Rhode Island
Sara Zarrella

Calgary, Ontario, Canada
Erin Shepley

North Andover, Massachusetts
Carol Doherty Maroney

Pomfret, Connecticut
Ryan Finnegan

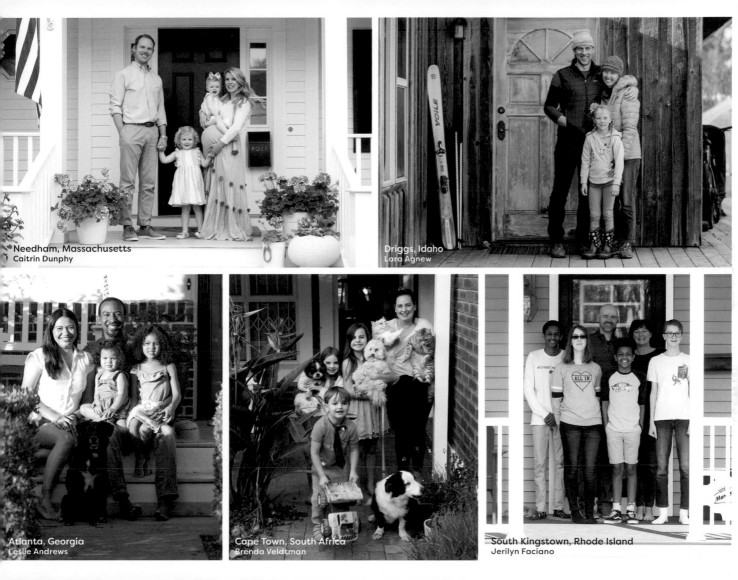

Needham, Massachusetts
Caitrin Dunphy

Driggs, Idaho
Lara Agnew

Atlanta, Georgia
Leslie Andrews

Cape Town, South Africa
Brenda Veldtman

South Kingstown, Rhode Island
Jerilyn Faciano

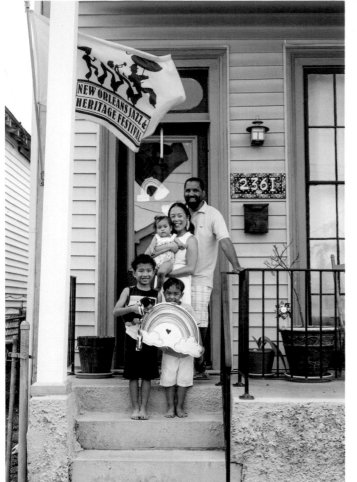

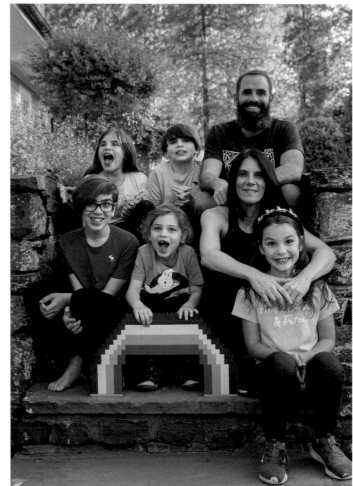

New Orleans, Louisiana Jillian Carruth Pelham, New York Jaye McLaughlin

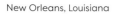

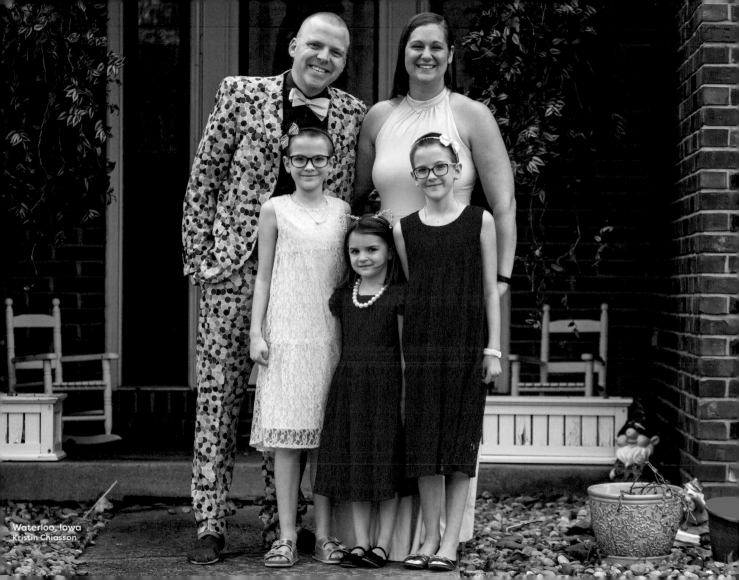

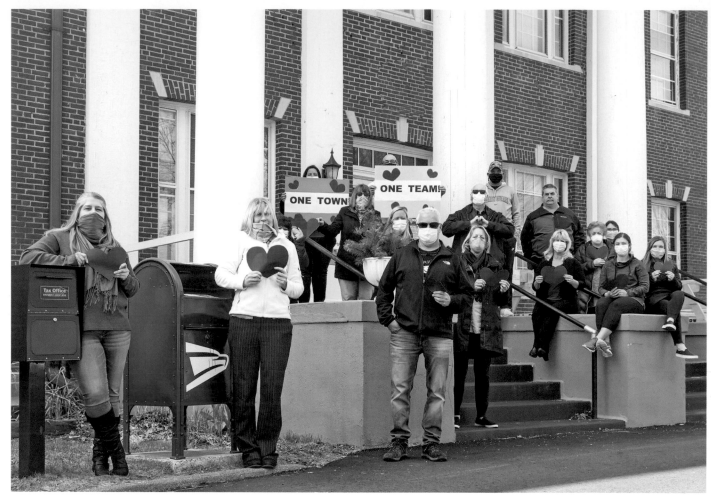

Hull, Massachusetts

Susan Hagstrom

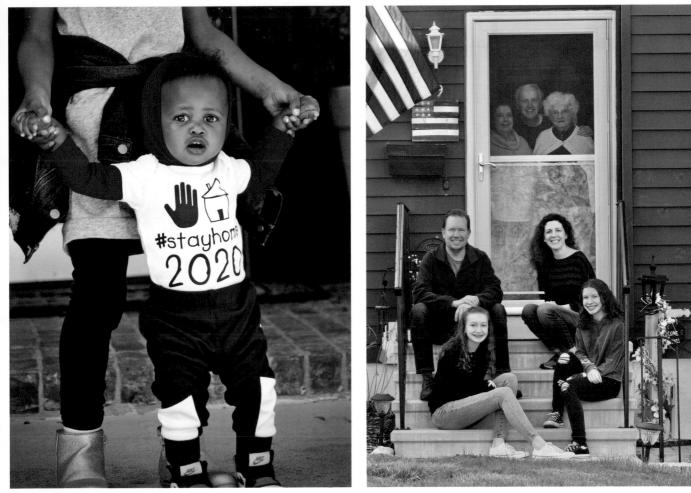

Grapevine, Texas

Rachna Argawal

Windsor, Connecticut

Leslie Massaro

43

> " Utilizing the same pay-it-forward spirit as The Front Steps Project, **we co-founded 'The Front Porch Project' in Baton Rouge.**
> Much of the success of our effort was due to a common understanding in the American South: **Everyone who can help, does.** In Louisiana, 'Southern Hospitality' isn't just a concept, it is in the blood. Together with participating photographers in Louisiana, Mississippi, and more, we raised more than $1.28 million for local businesses.

Jenn Ocken and Aimee Supp,
Baton Rouge, Louisiana

Baton Rouge, Louisiana Taylor Watson

St. Francisville, Louisiana Jenn Ocken

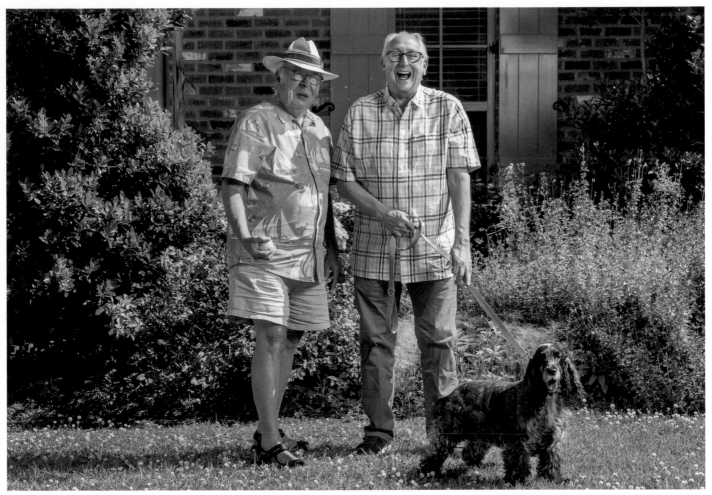

Baton Rouge, Louisiana

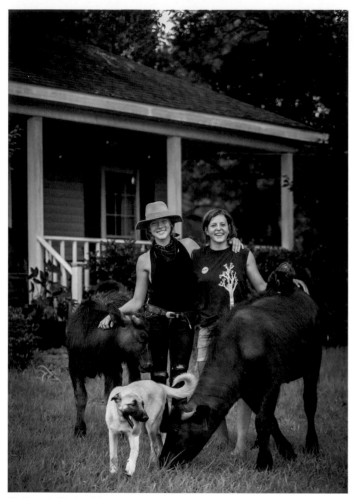

St. Francisville, Louisiana

Jenn Ocken

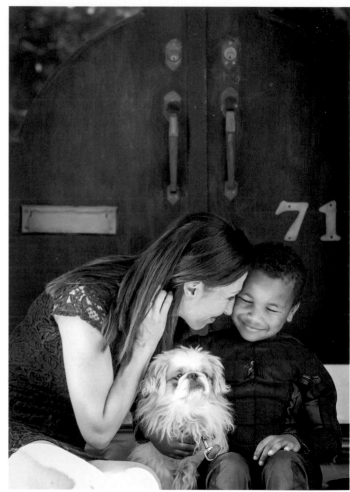

Baton Rouge, Louisiana

Jenn Ocken

Baton Rouge, Louisiana Jenn Ocken

"It was amazing to see our community show up for each other... Immediately, without hesitation, we decided we were going to get through it together!"

Jenn Ocken, Baton Rouge, Louisiana

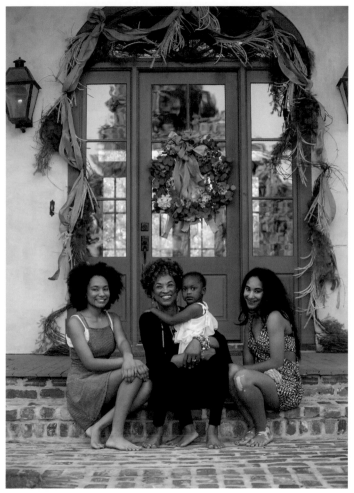

Baton Rouge, Louisiana Jenn Ocken

Daniel Island,
South Carolina
Tiffany Mizzell

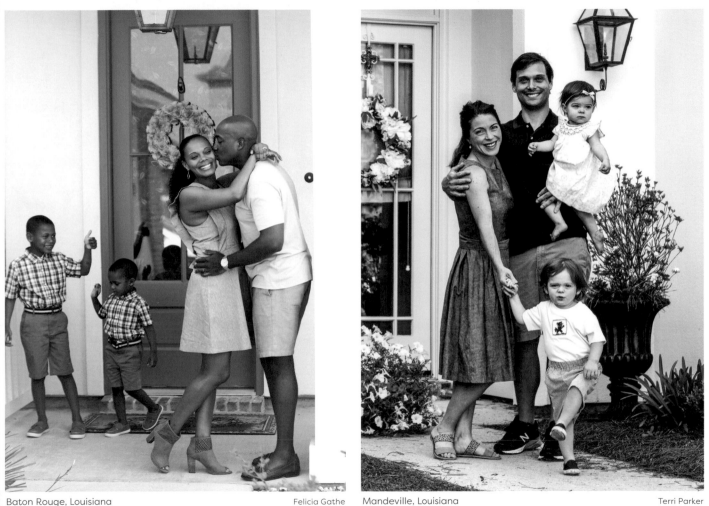

Baton Rouge, Louisiana

Felicia Gathe

Mandeville, Louisiana

Terri Parker

Hoboken, New Jersey

Kim Gerlach

Fort Wayne, Indiana

Bambi Guthrie

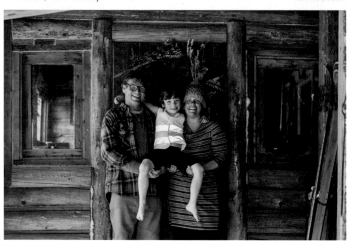

Alta, Wyoming

Lara Agnew

Santa Fe, New Mexico

Christy Parent

Somerville, Massachusetts
Kristen Fuller

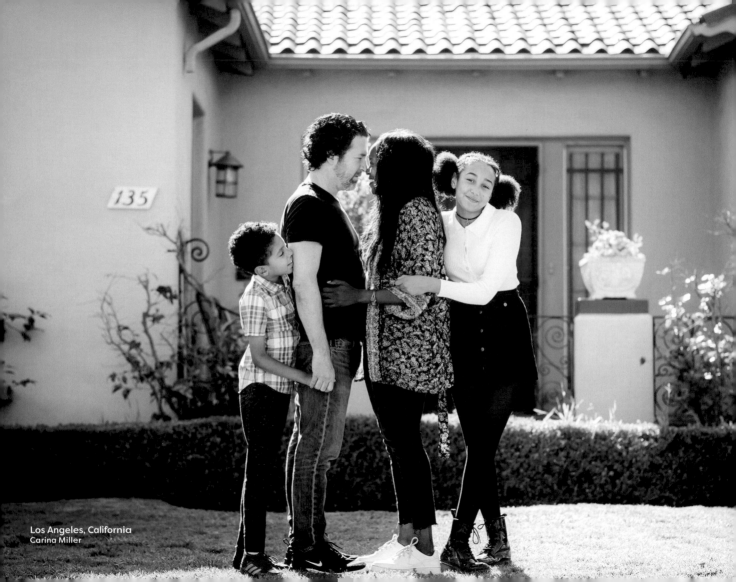

Los Angeles, California
Carina Miller

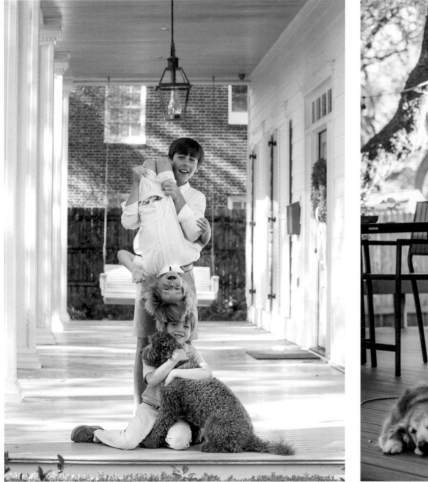

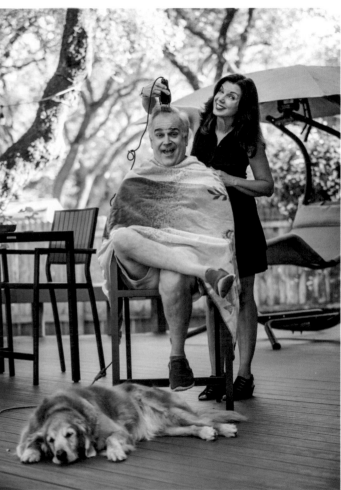

Baton Rouge, Louisiana Jenn Ocken

Austin, Texas April and Amy Rankin

53

"As quickly as COVID arrived, the community showed **KINDNESS**. They came together to help each other, raising money, making thousands of masks… you name it, this community stepped up. Despite the inherent dangers of connecting with each other, the pandemic seemed to bring out the best in people."

Xenia Gross, Wilton, Connecticut

Biloxi, Mississippi
Jessica Holland

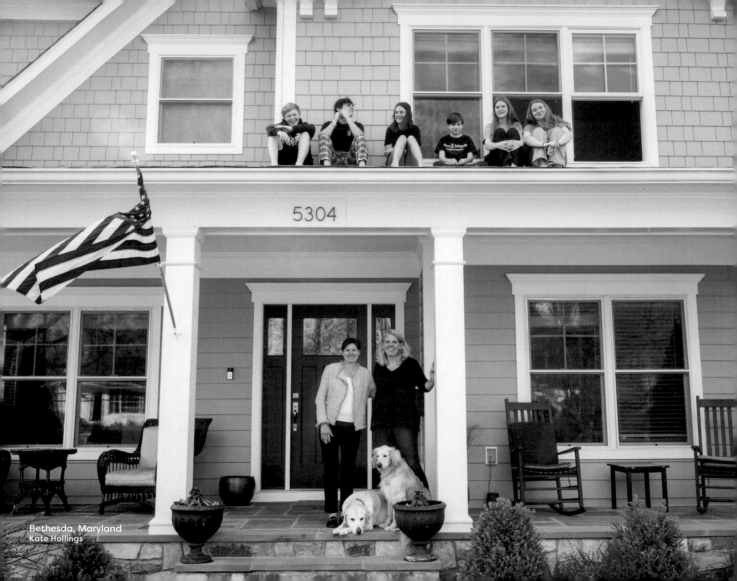

5304

Bethesda, Maryland
Kate Hollings

Burnsville, Minnesota Susan Coyne

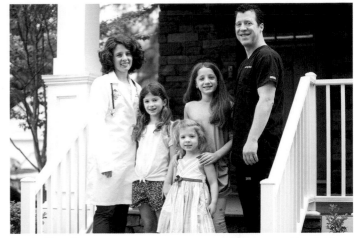

Leonia, New Jersey Marc Goldberg

Brooklyn, New York Marj Kleinman

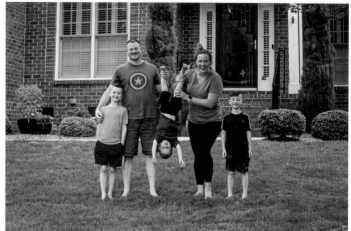

Mooresville, North Carolina — Kathleen and Ed Martin

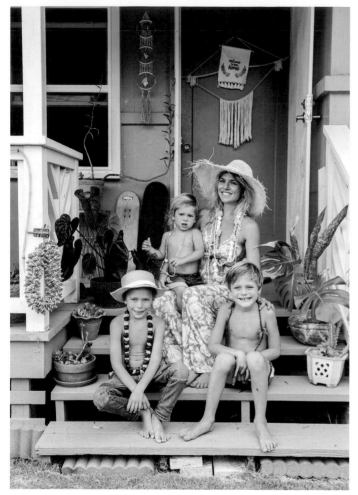

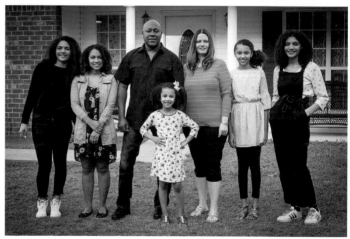

Corinth, Mississippi — Michelle Gifford

Kailua, Hawaii — Alicia Camacho

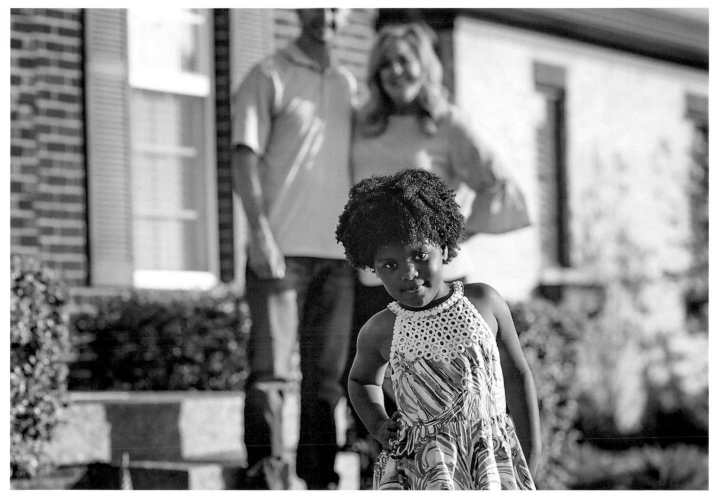

Louisville, Kentucky

Kate Vogel

DAY 30

DAY 35

DAY 32

DAY

DAY 29

Mooresville, North Carolina
Kathleen and Ed Martin

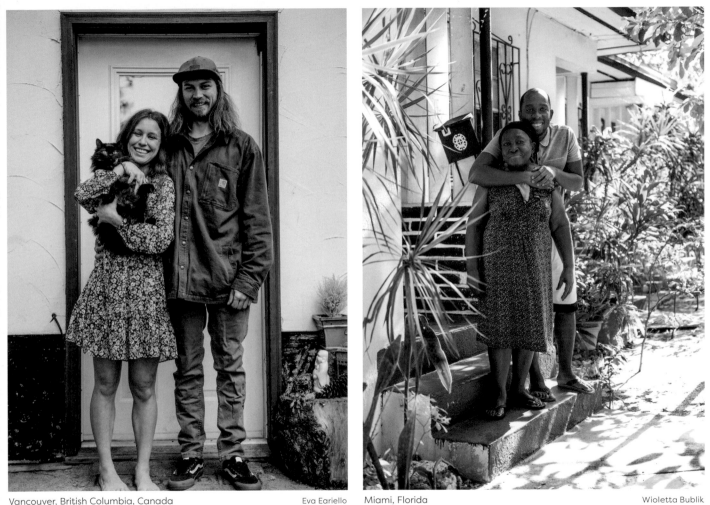

Vancouver, British Columbia, Canada Eva Eariello

Miami, Florida Wioletta Bublik

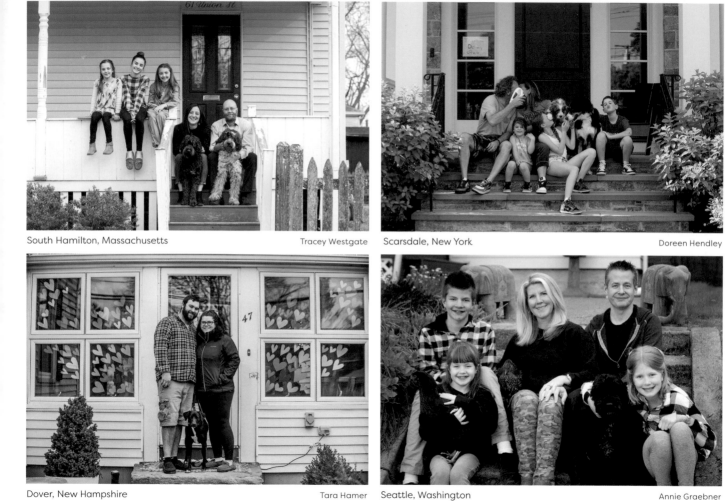

South Hamilton, Massachusetts Tracey Westgate

Scarsdale, New York Doreen Hendley

Dover, New Hampshire Tara Hamer

Seattle, Washington Annie Graebner

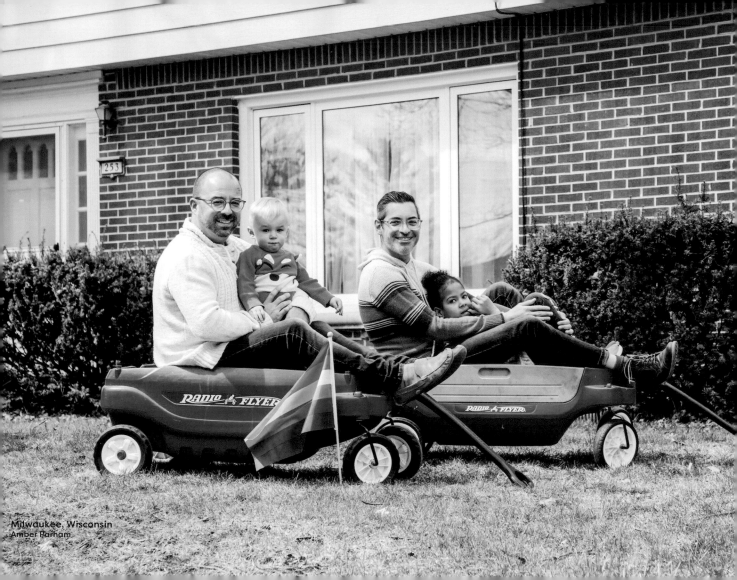

Milwaukee, Wisconsin
Amber Parham

"I was living in downtown NYC on September 11, 2001. I witnessed the devastation and great loss first hand. **When the coronavirus pandemic arose in March 2020, the memories of 9/11 came flooding back.** I felt helpless and I didn't know what to do. I read about The Front Steps Project one evening and I started shooting the very next day. **I was told by many that the photo sessions were the highlight of their day.**

Mary Wade, Darien, Connecticut

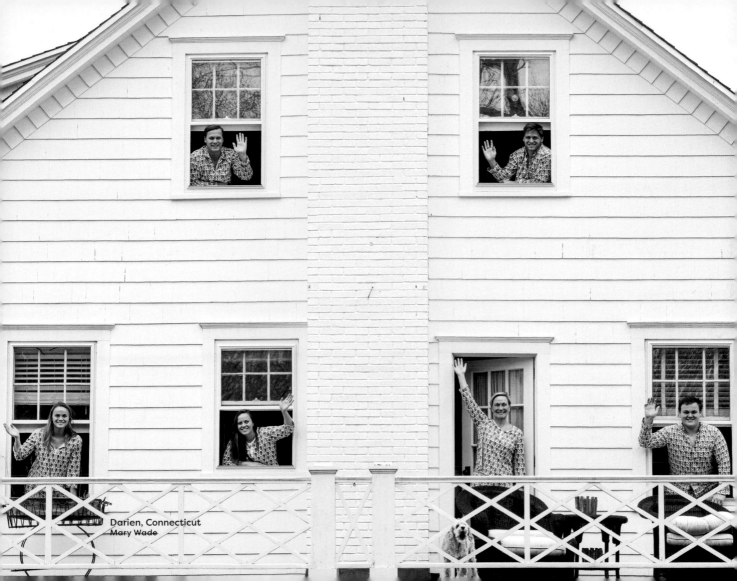

Darien, Connecticut
Mary Wade

Harlem, New York
Marc Goldberg

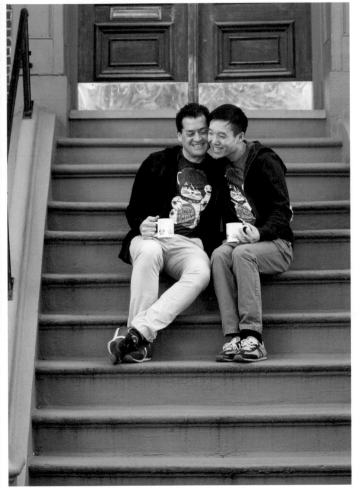

Boston, Massachusetts

Emily O'Brien

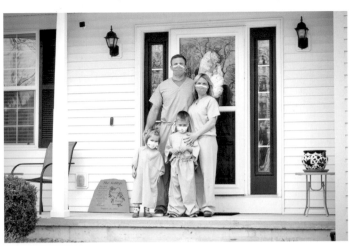

Jamesville, New York

Katie Hooks

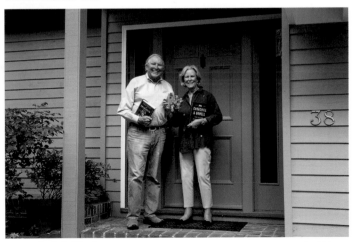

San Rafael, California

Jen Skinner

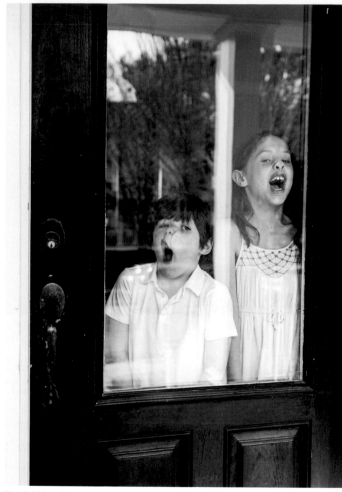

Daniel Island, South Carolina

Tiffany Mizzell

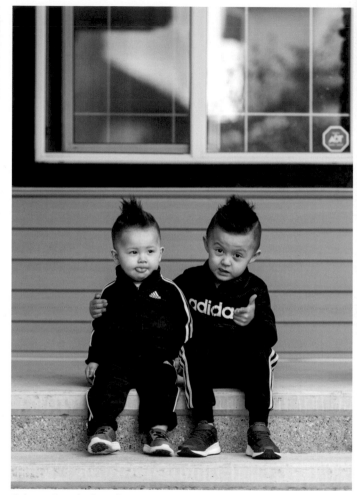

Calgary, Ontario, Canada

Erin Shepley

Hoboken, New Jersey
Kris Knesel

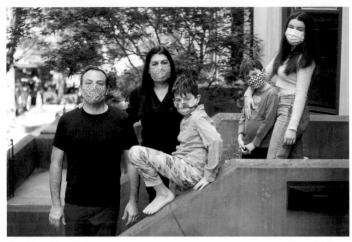

Brooklyn, New York Marc Goldberg

Victor, Idaho Lara Agnew

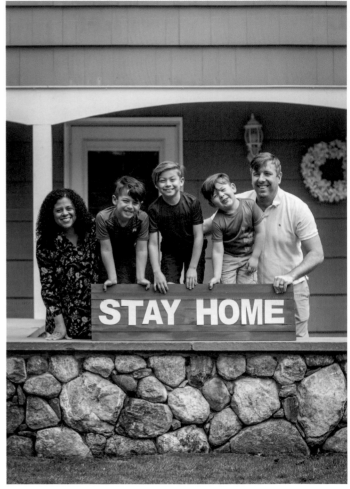

Wilton, Connecticut Xenia Gross

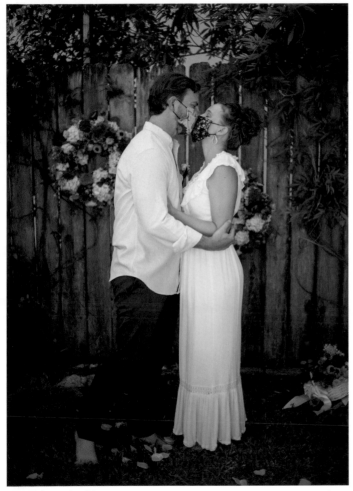

New Orleans, Louisiana

Cindy Abney

Faxon, Oklahoma

Stacy Pearce

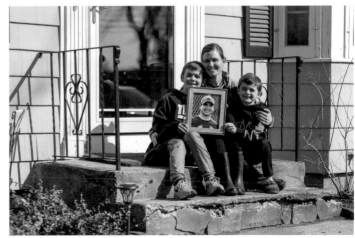

Suffield, Connecticut

Rob Faber

71

Beaconsfield, Quebec, Canada

Sophy Hurtubise

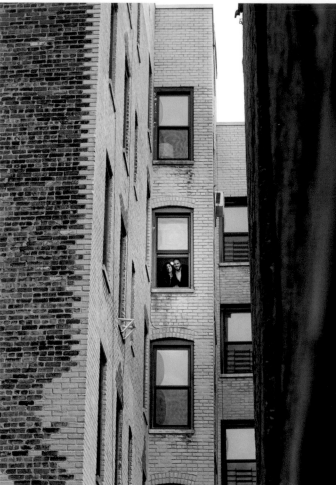

Brooklyn, New York

Naftali Marasow

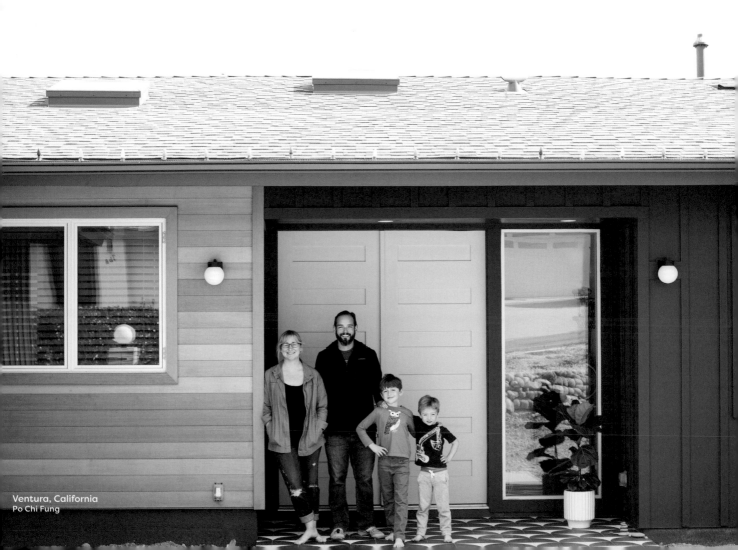

Ventura, California
Po Chi Fung

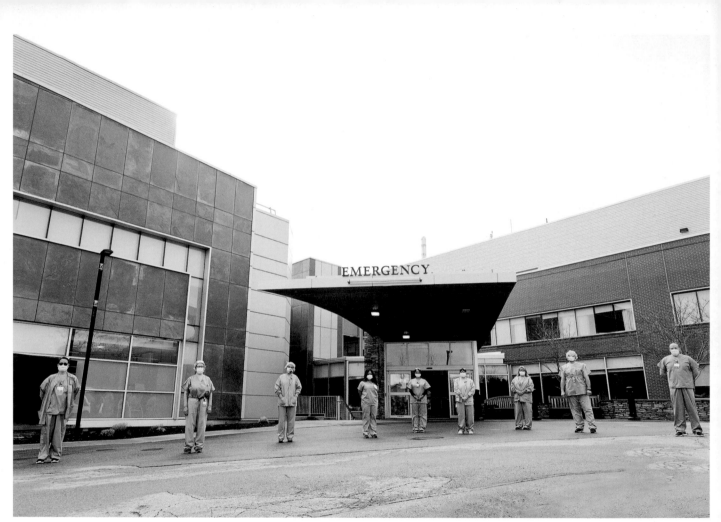

Needham, Massachusetts

"Through this project I was blessed to witness and document people's love for one another, their connection to each other, their strength, and their **COURAGE** through one of the most difficult times in history. Most of all, I felt their joy and gratitude when I arrived to photograph them, even from a distance."

Jerilyn Faciano, South Kingstown, Rhode Island

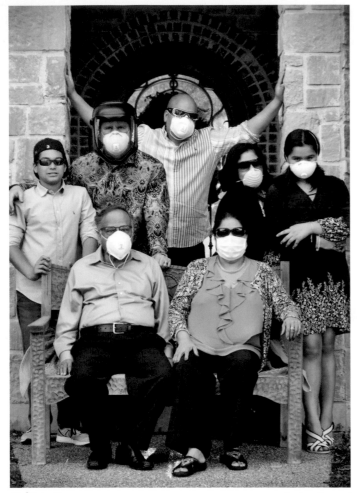

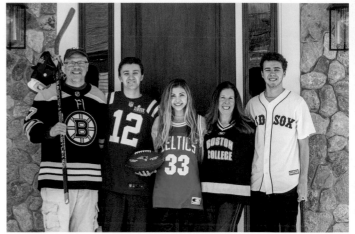

Needham, Massachusetts Topher Cox

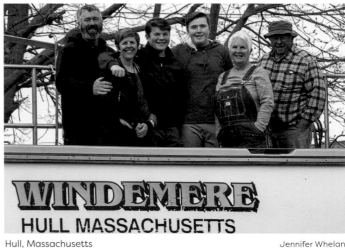

Westlake, Texas Rachna Argawal

Hull, Massachusetts Jennifer Whelan

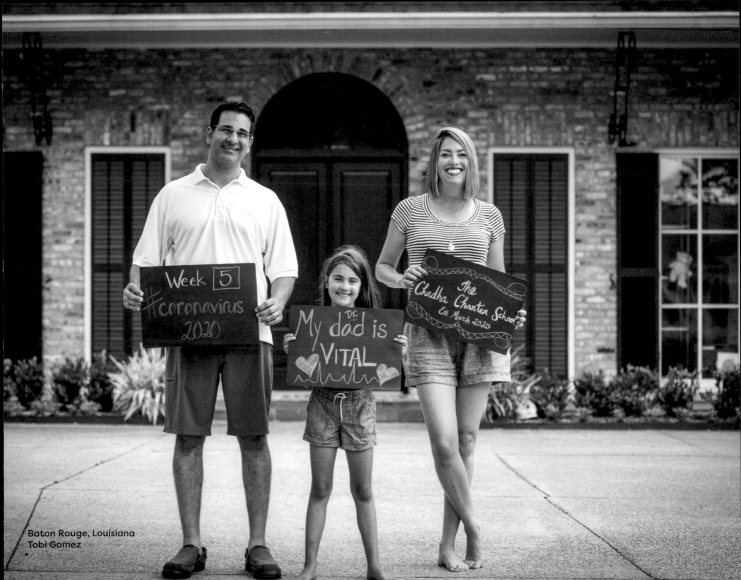

Week 5
#coronavirus
2020

My Dr. dad is
VITAL

The Chadha Charter School
Est March 2020

Baton Rouge, Louisiana
Tobi Gomez

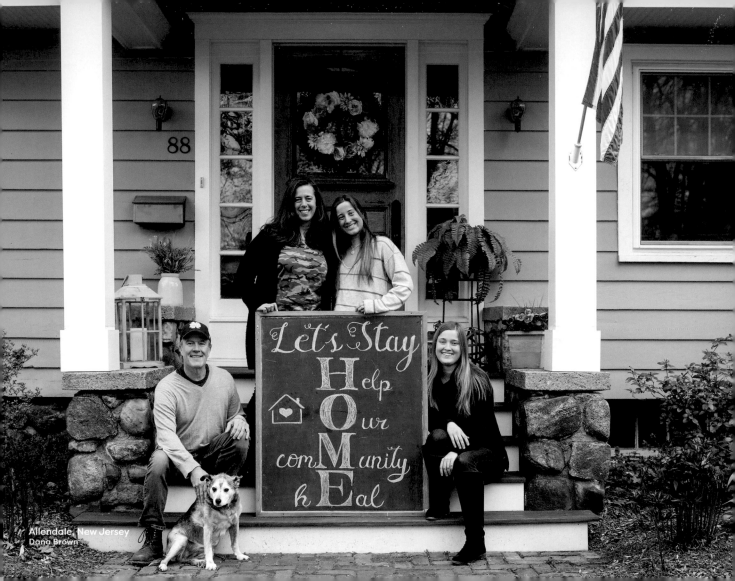

Allendale, New Jersey
Dana Brown

Let's Stay **HOME**
Help
Our
com**M**unity
h**E**al

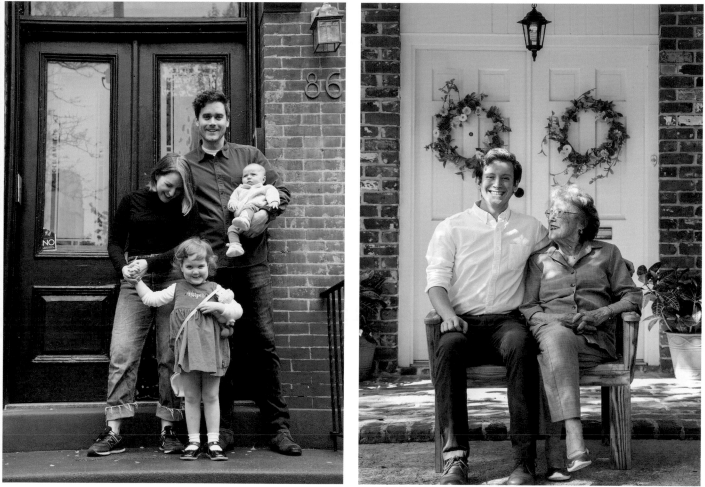

Brooklyn, New York

Vanessa Ryan

Baton Rouge, Louisiana

Beth Curry LeBlanc

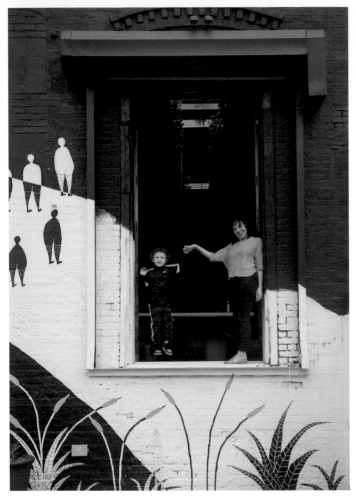

Brooklyn, New York Shrutti Garg

Montreal, Quebec, Canada Ryan Blau

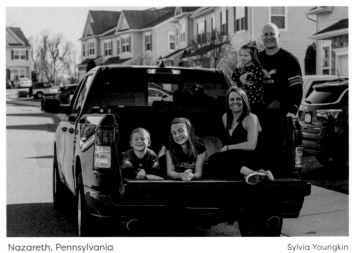

Nazareth, Pennsylvania Sylvia Youngkin

Seattle, Washington
AV Goodsell

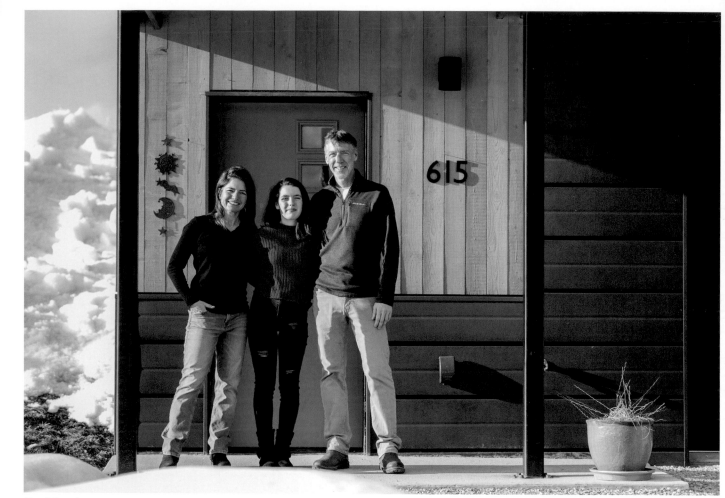

Alta, Wyoming

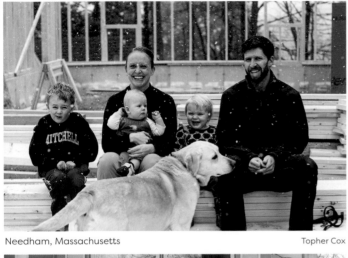

Needham, Massachusetts Topher Cox

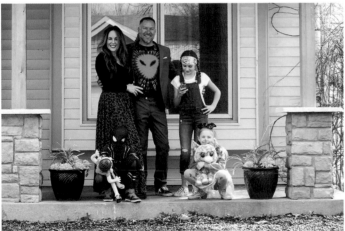

Lawrence, Kansas Trina Baker

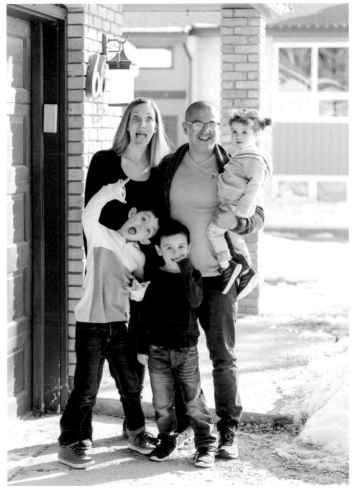

Winnipeg, Manitoba, Canada Casey Nolin

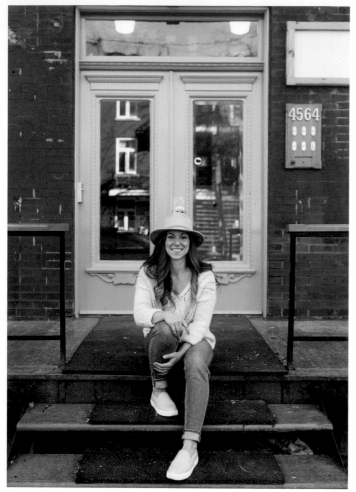

Montreal, Quebec, Canada

Charlotte Boileau-Domingue

"These are photos of the same woman, one off duty and the other on her way to work as a nurse. It is a reminder that **our healthcare workers are just regular people who are forced to be beyond brave.**"

Charlotte Boileau-Domingue,
Montreal, Quebec, Canada

Montreal, Quebec, Canada
Charlotte Boileau-Domingue

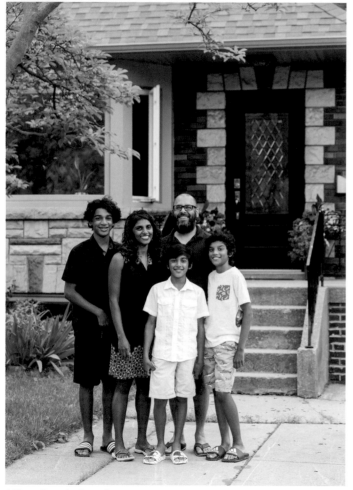

Milton, Ontario, Canada

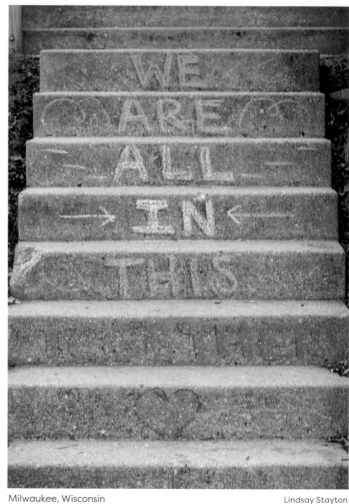

Milwaukee, Wisconsin

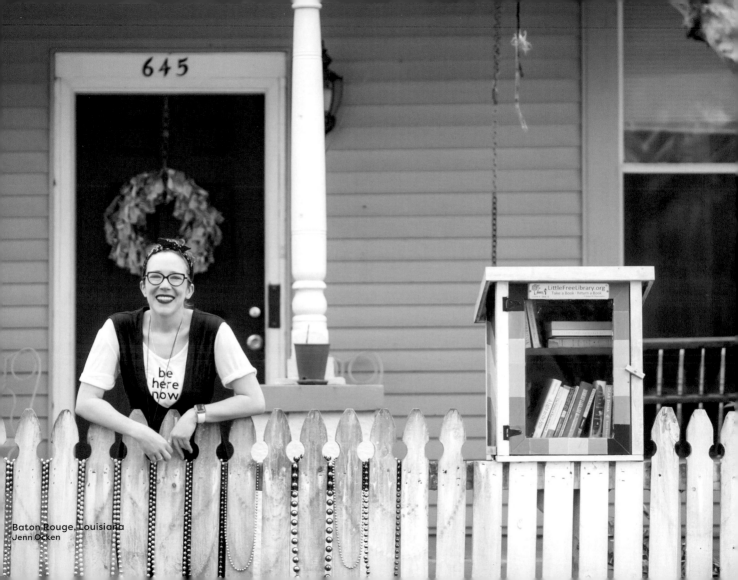

Baton Rouge, Louisiana
Jenn Ocken

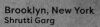

Brooklyn, New York
Shrutti Garg

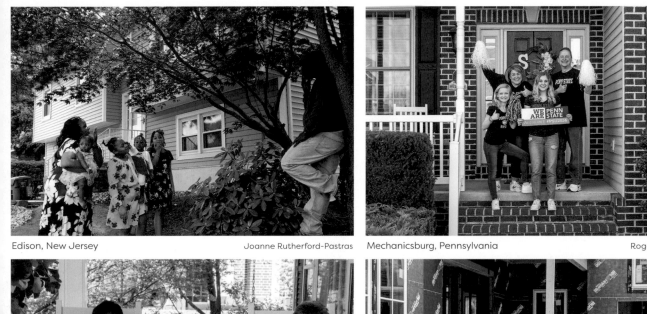

Edison, New Jersey Joanne Rutherford-Pastras

Mechanicsburg, Pennsylvania Roger Baumgarten

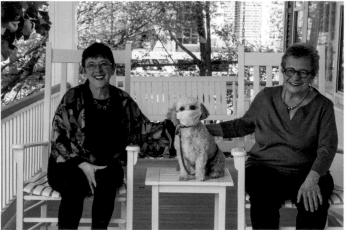

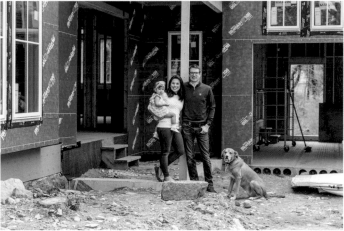

West Hartford, Connecticut Christine Breslin

Cohasset, Massachusetts An LeFevre

Victor, Idaho

Lara Agnew

Waukee, Iowa

Monica Van Ess

Montreal, Quebec, Canada

Tzivi Wenger

Columbus, Ohio

Erin Brown

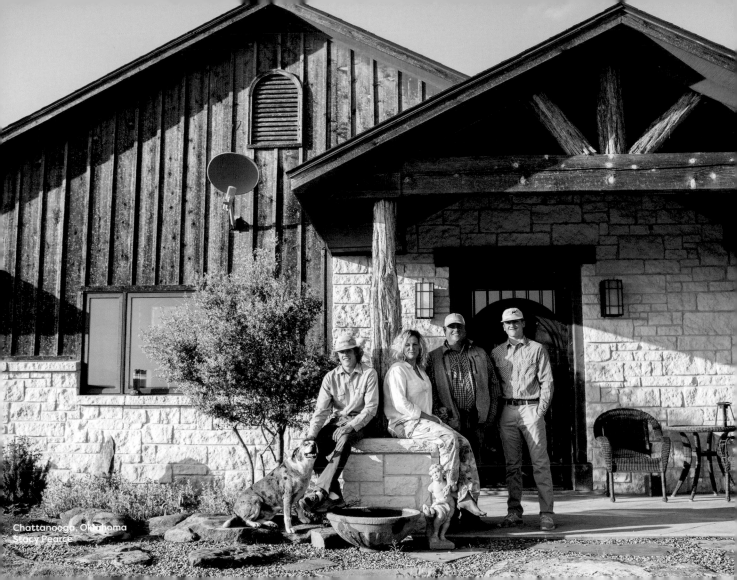

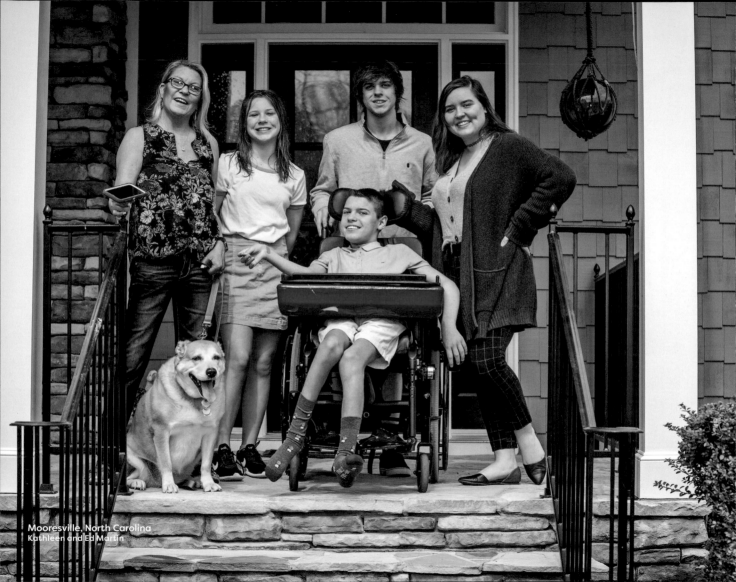

Mooresville, North Carolina
Kathleen and Ed Martin

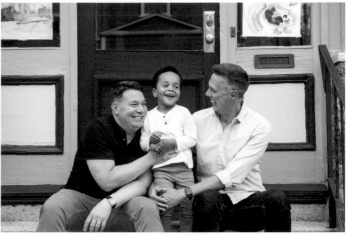

New Rochelle, New York Lori Carlton

Dorchester, Massachusetts Nan Patriquin

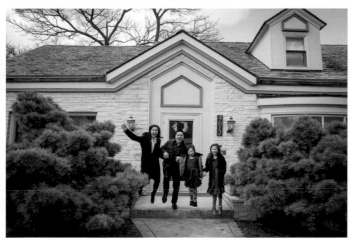

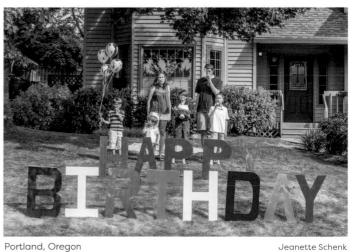

Milwaukee, Wisconsin Lindsay Stayton

Portland, Oregon Jeanette Schenk

"I was desperate for fun and I suspected others might be, too. I put a notice on social media hoping people would bite... The response was overwhelming. There were themes, costumes, signs, banners, and just plain old good clean fun. Turns out, COVID could not kill **HUMOR**."

Danielle Coleman, Old Greenwich, Connecticut

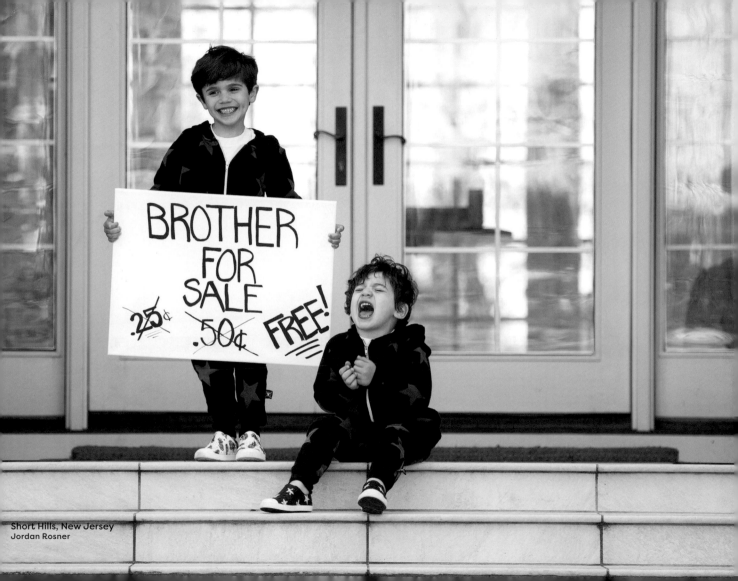

BROTHER FOR SALE ~~.25¢~~ ~~.50¢~~ FREE!

Short Hills, New Jersey
Jordan Rosner

Faxon, Oklahoma Stacy Pearce

Needham, Massachusetts Cara Soulia

Seattle, Washington Annie Graebner

Mooresville, North Carolina Kathleen and Ed Martin

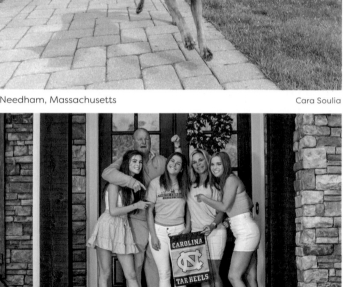

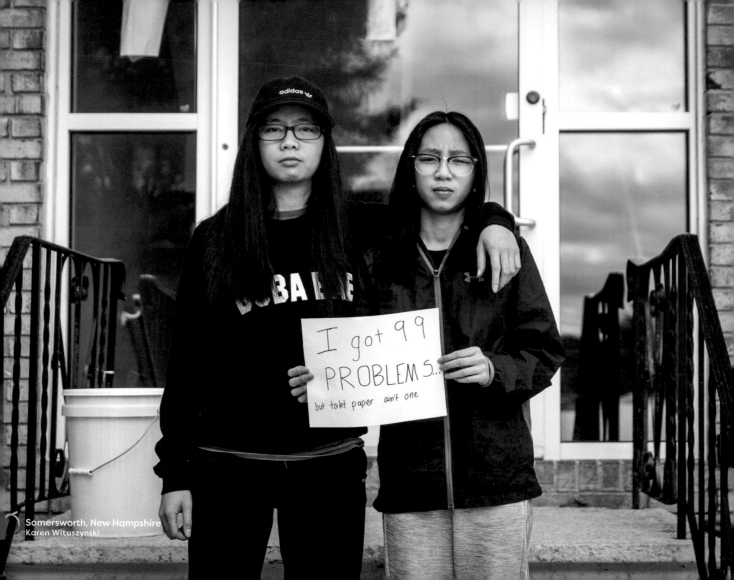

I got 99 PROBLEMS...
but toilet paper ain't one

Somersworth, New Hampshire
Karen Wituszynski

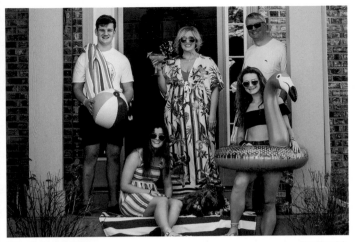

Westfield, Indiana

Jen Sherrick

Fairport, New York

Maura Kerkezis

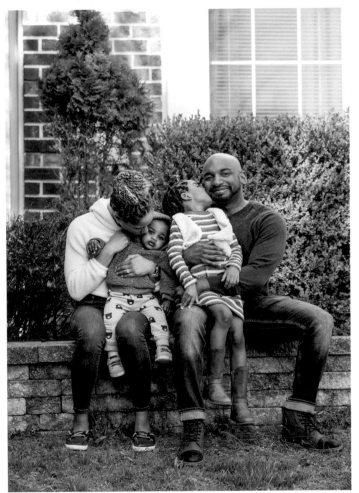

Owings Mills, Maryland

Mary Pedersen

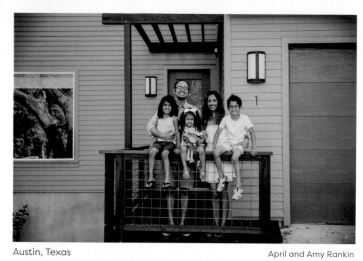

Austin, Texas

April and Amy Rankin

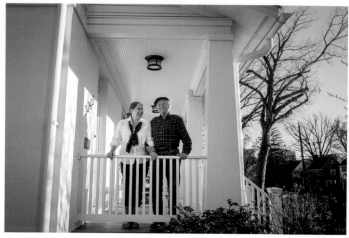

Arlington, Virginia

Sarah Goldman

Victor, Idaho

Lara Agnew

Borex, Switzerland

Anna De Wit

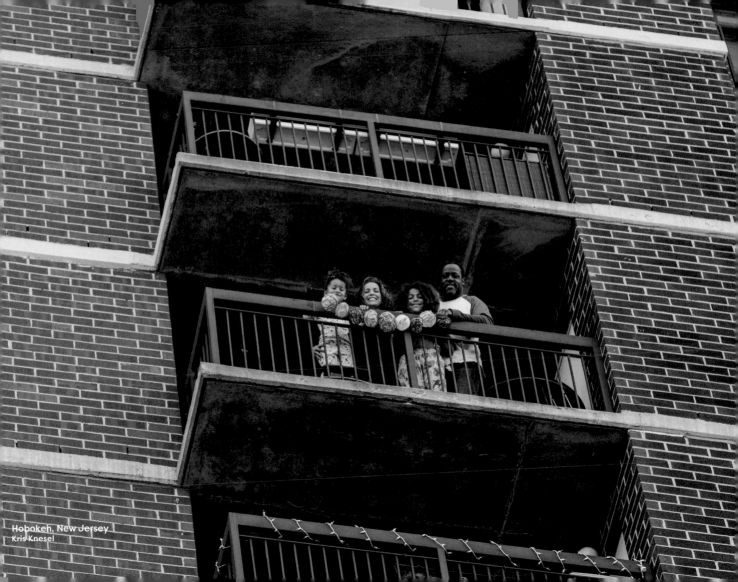

Hoboken, New Jersey
Kris Knesel

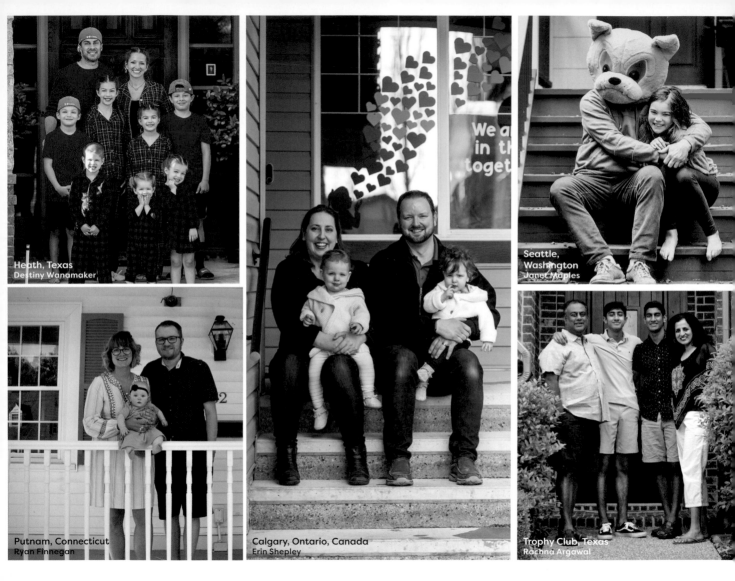

Heath, Texas
Destiny Wanamaker

Seattle,
Washington
Janet Maples

Putnam, Connecticut
Ryan Finnegan

Calgary, Ontario, Canada
Erin Shepley

Trophy Club, Texas
Rachna Argawal

We a
in th
toget

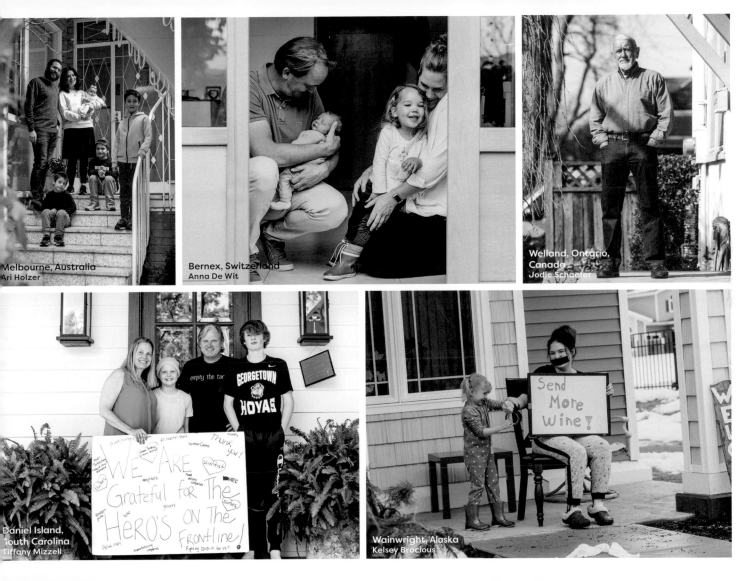

Melbourne, Australia
Ari Holzer

Bernex, Switzerland
Anna De Wit

Welland, Ontario,
Canada
Jodie Schaefer

Daniel Island,
South Carolina
Tiffany Mizzell

WE ARE Grateful for The HERO'S on The Frontline!

Wainwright, Alaska
Kelsey Brocious

Send More Wine!

"When I arrived, I was struck by how perfectly arranged these neighbors were at their **socially distanced cocktail hour**. They proudly produced a measuring tape to prove their adherence to the six-foot rule. I asked if they were ready for their photo. They agreed, although, in hindsight, they seemed a bit puzzled. I snapped a few frames and said I was on my way to the next house on my list. "What list?" they asked. Turns out I was at the wrong address! The whole thing felt serendipitous. **I walked away from the wrong house with very much the right photo on my memory card.**

Cara Soulia, Needham, Massachusetts

Needham, Massachusetts
Cara Soulia

Cardiff-by-the-Sea, California

Melissa Au

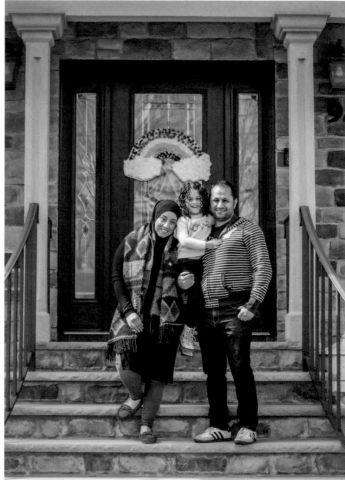

Union City, New Jersey

Jennisse Uy

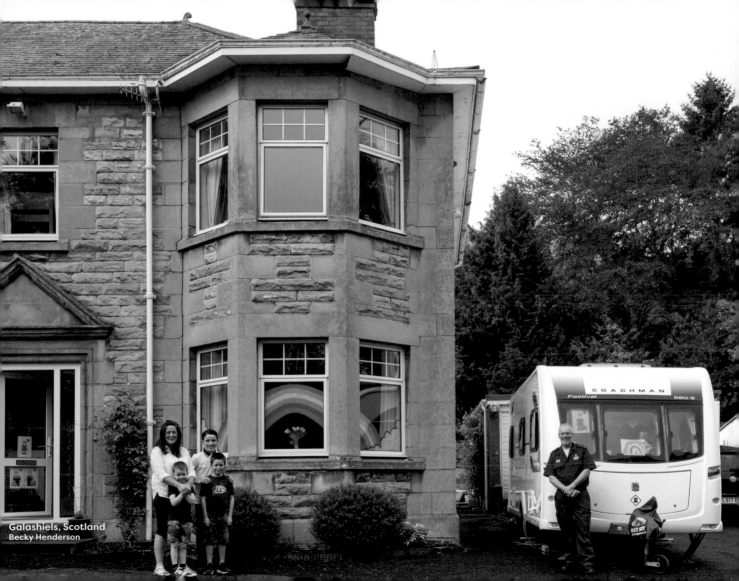

Galashiels, Scotland
Becky Henderson

Buda, Texas
April and Amy Rankin

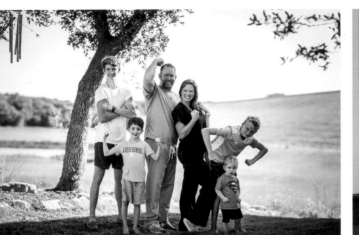

Leander, Texas April and Amy Rankin

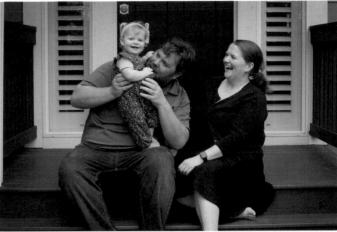

Seattle, Washington Annie Graebner

North Andover, Massachusetts Mary Schwalm

Glen Rock, New Jersey Jodi Crandell

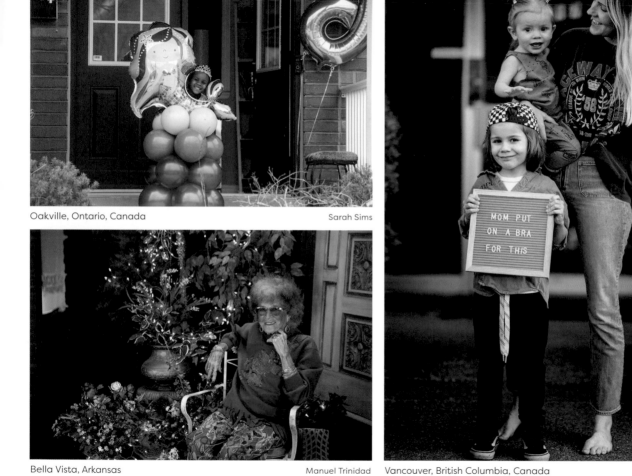

Oakville, Ontario, Canada — Sarah Sims

Bella Vista, Arkansas — Manuel Trinidad

Vancouver, British Columbia, Canada — Eva Eariello

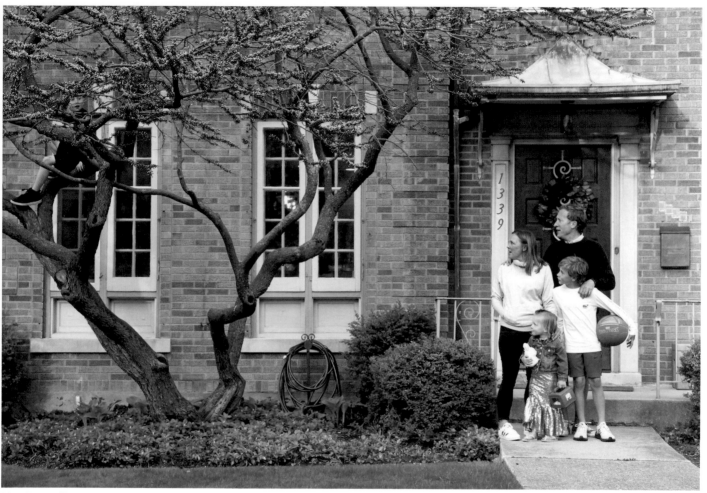

River Forest, Illinois

Steve Beck

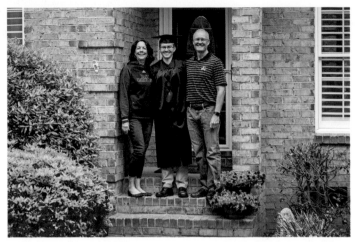

Mooresville, North Carolina Kathleen and Ed Martin

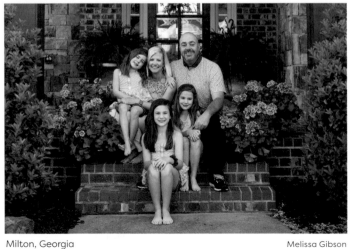

Milton, Georgia Melissa Gibson

Portland, Jamaica Marina Burnel

"This is perhaps my favorite portrait. Nearly **100-year-old Lucille** told me that she is thankful for her daughter, letters from her priest, and that she is still able to garden. I felt so very **BLESSED** to meet this darling lady!"

Linda Osborne, New Ulm, Minnesota

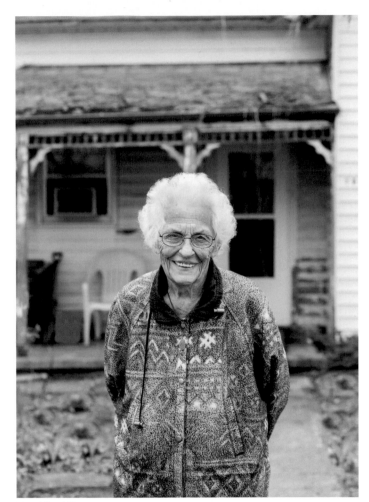

New Ulm, Minnesota

Linda Osborne

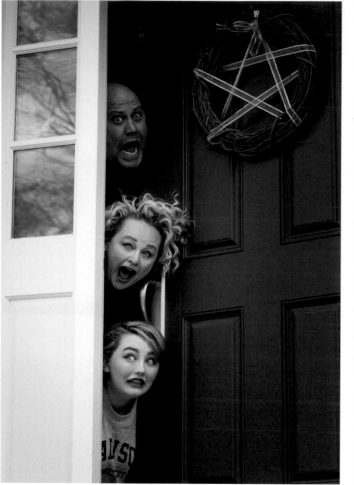

Madison, Connecticut

Cindy Ringer

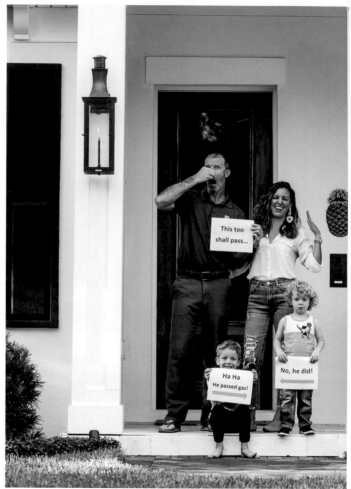

Tampa, Florida

Amy Pezzicara

Waterloo, Iowa
Kristin Chiasson

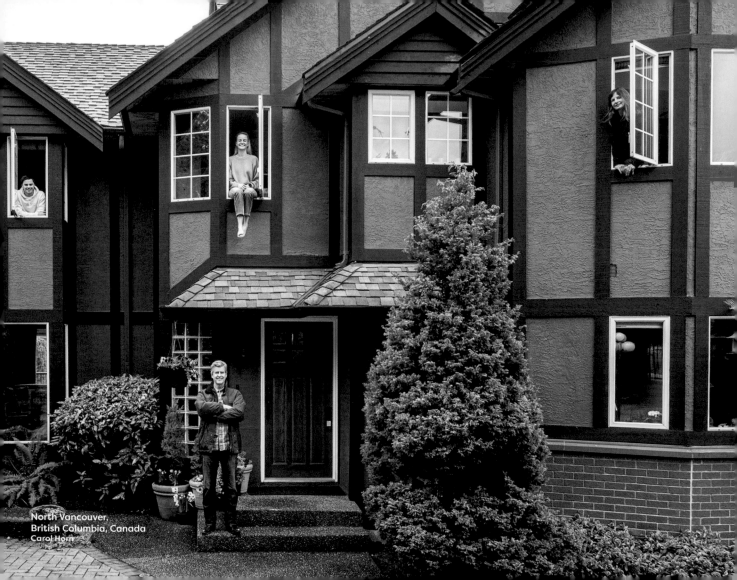

North Vancouver,
British Columbia, Canada
Carol Horn

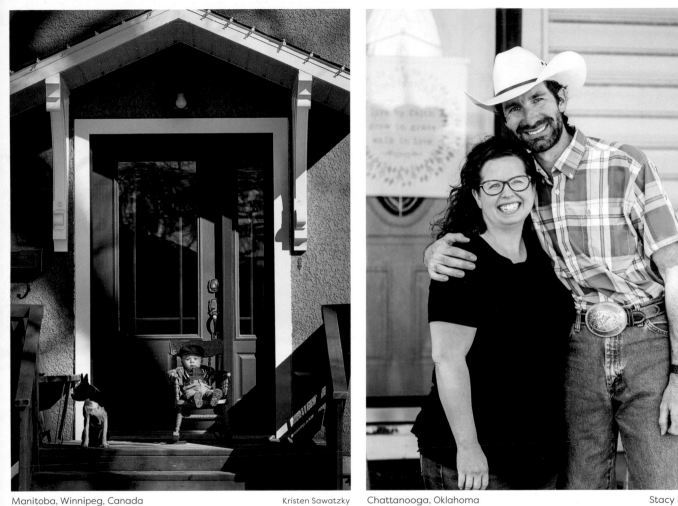

Manitoba, Winnipeg, Canada Kristen Sawatzky

Chattanooga, Oklahoma Stacy Pearce

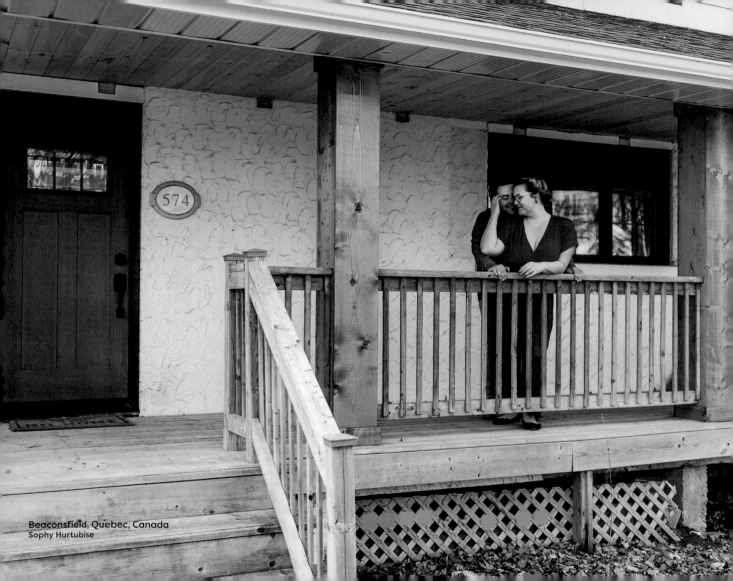

Beaconsfield, Quebec, Canada
Sophy Hurtubise

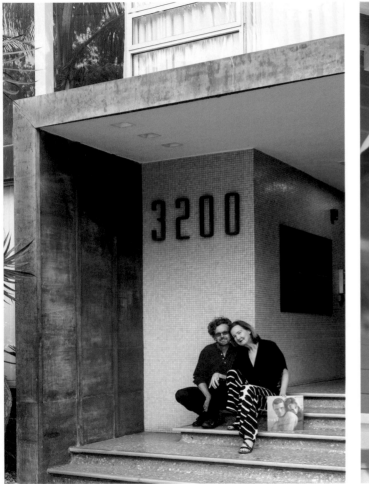

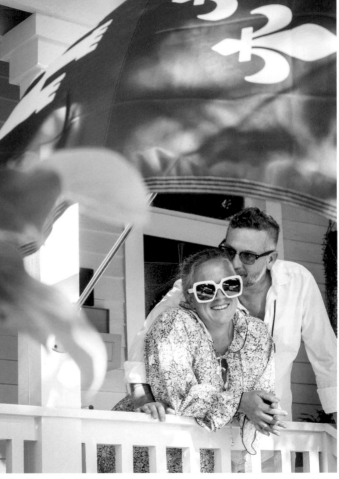

San Diego, California

Melissa Au

Baton Rouge, Louisiana

Jenn Ocken

119

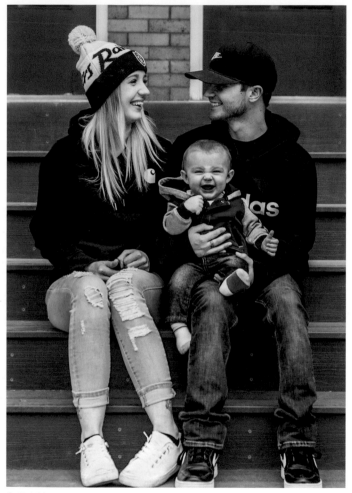

Butte, Montana

Hunter Blodgett

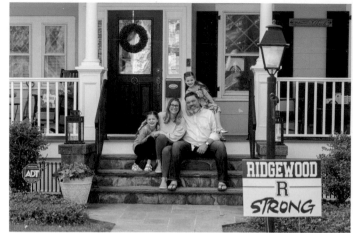

Ridgewood, New Jersey

Lena Antaramian

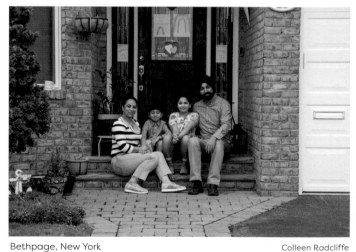

Bethpage, New York

Colleen Radcliffe

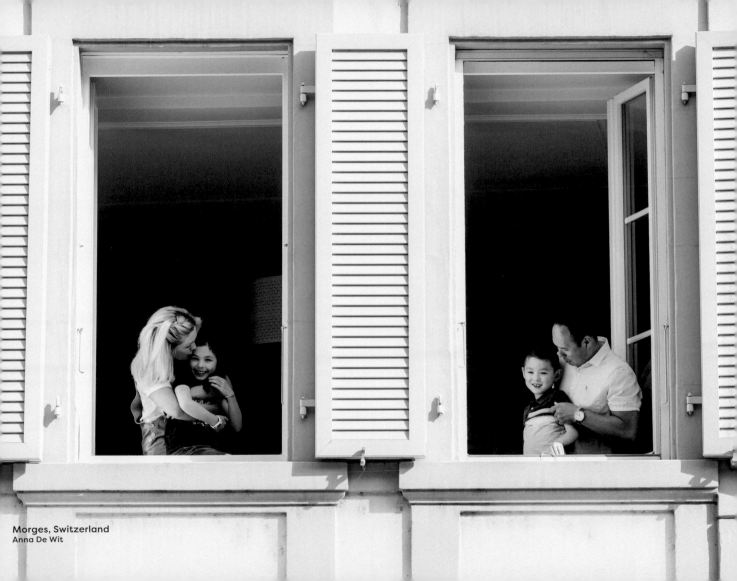

Morges, Switzerland
Anna De Wit

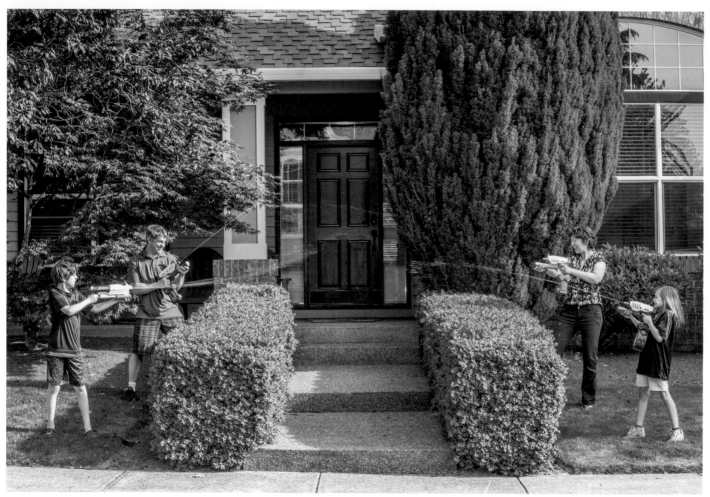

Portland, Oregon

Jeanette Schenk

"Every time I went to a new house, it seemed like everyone was at **PLAY**—creating chalk art on the sidewalk, playing music on the patio, kicking a soccer ball in the yard. It gave me a great sense of ease and community. I felt like everything would all be okay."

Timolyn Essen, Boulder, Colorado

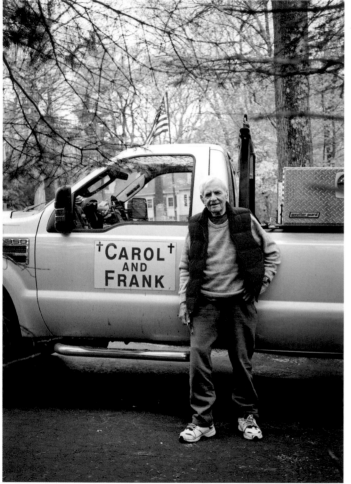

Needham, Massachusetts — Kate King

Vancouver, British Columbia, Canada — Laura-Lee Gerwing

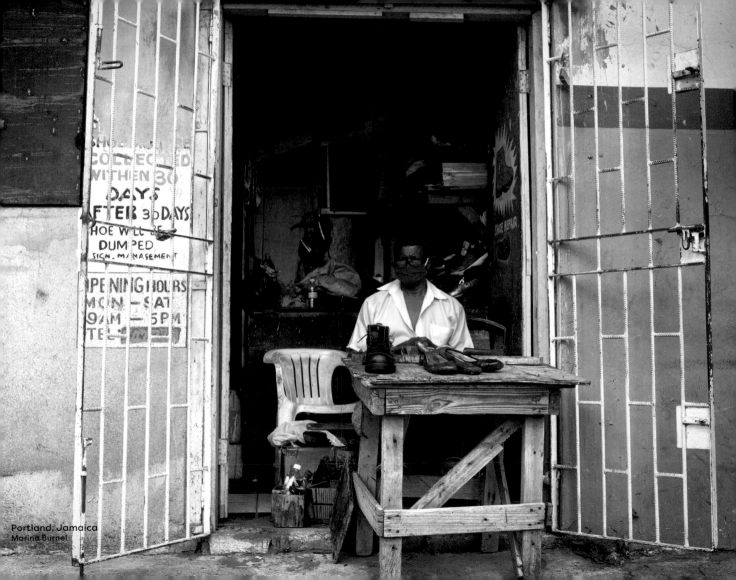

Portland, Jamaica
Marina Burnel

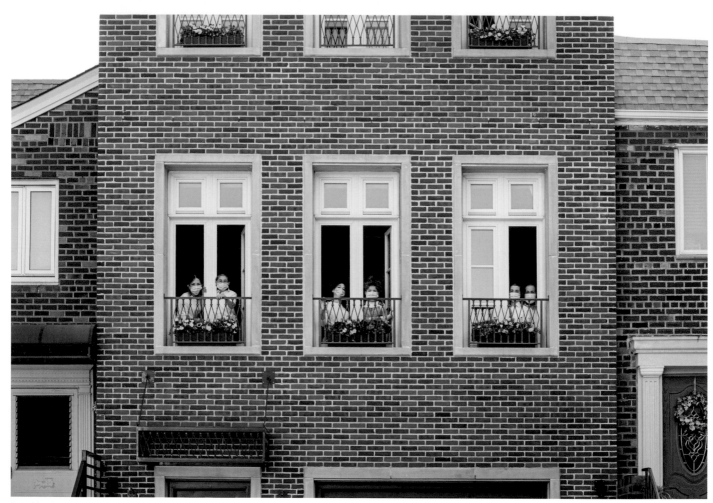

Brooklyn, New York

Naftali Marasow

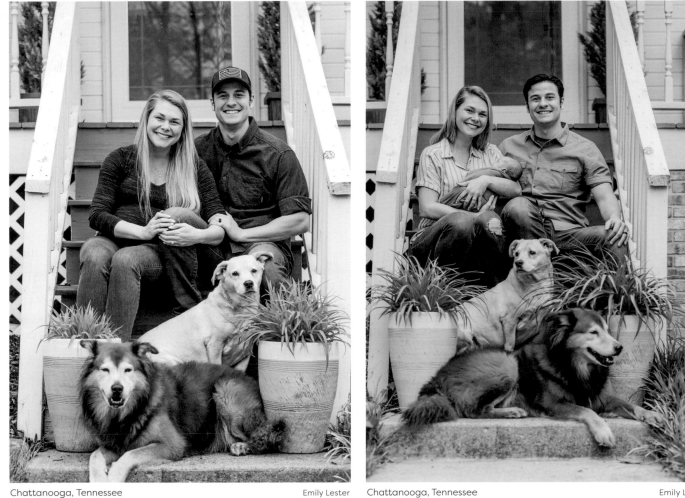

Chattanooga, Tennessee

Emily Lester

Chattanooga, Tennessee

Emily Lester

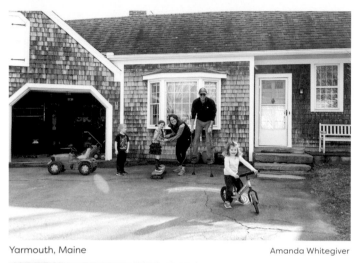

Yarmouth, Maine — Amanda Whitegiver

Sydney, Australia — Marie Berroa

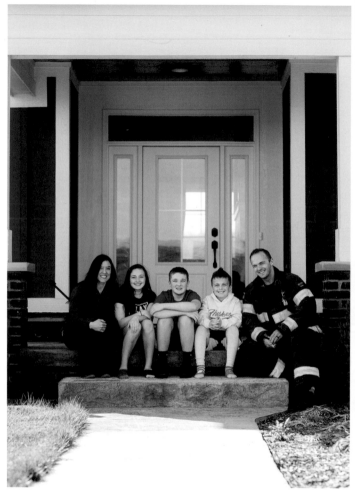

Westfield, Indiana — Amy Vyverberg

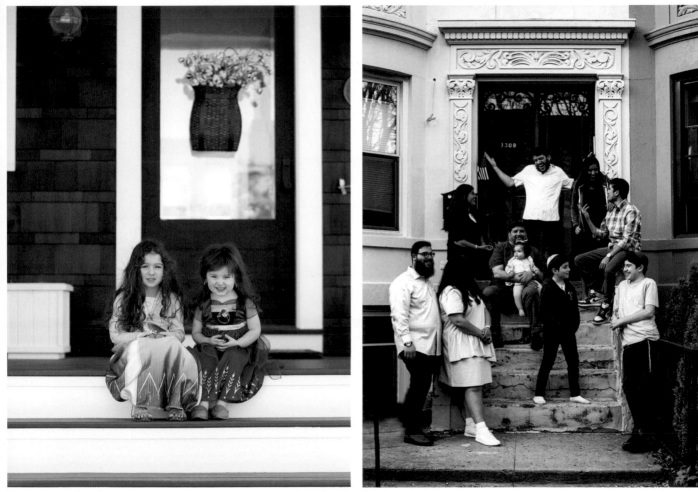

Exeter, Rhode Island Sara Zarrella Brooklyn, New York Naftali Marasow

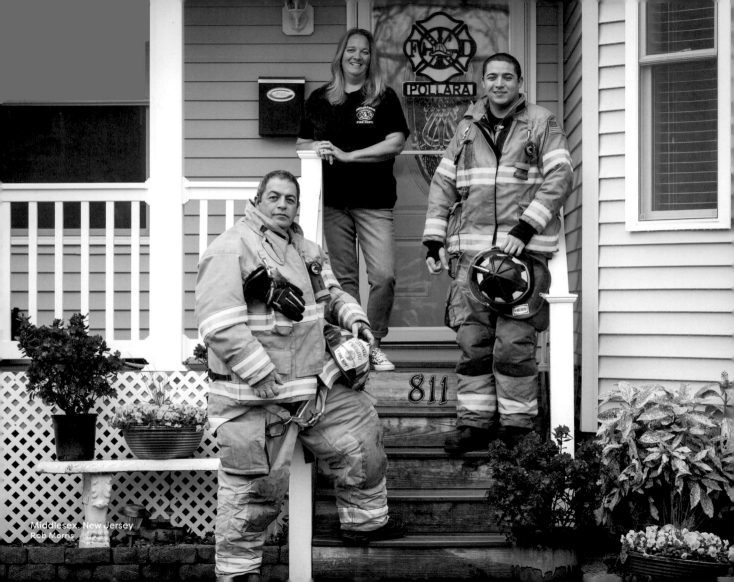

" I was scheduled to visit my daughter in Los Angeles for her birthday the week of March 23rd. The trip was canceled, **so I looked to fill the void by helping my community.** Inspired by The Front Steps Project, **a friend and I formed 'The Friends of Middlesex Borough' to raise money for the needy and first responders.** I decided to continue our nonprofit after the COVID crisis is over to help even more people in our community.

Rob Morris, Middlesex, New Jersey

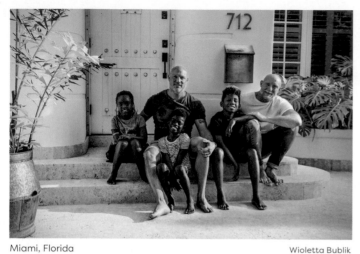

Miami, Florida

Wioletta Bublik

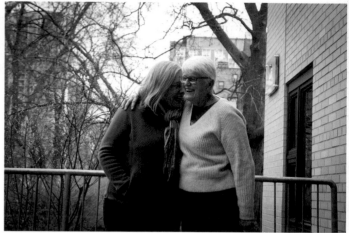

Milwaukee, Wisconsin

Lindsay Stayton

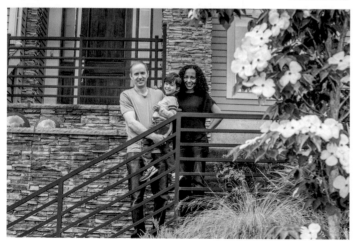

Beaverton, Oregon

Jeanette Schenk

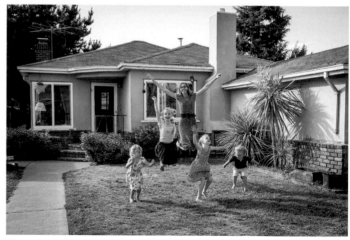

Alameda, California

Stephanie Brand

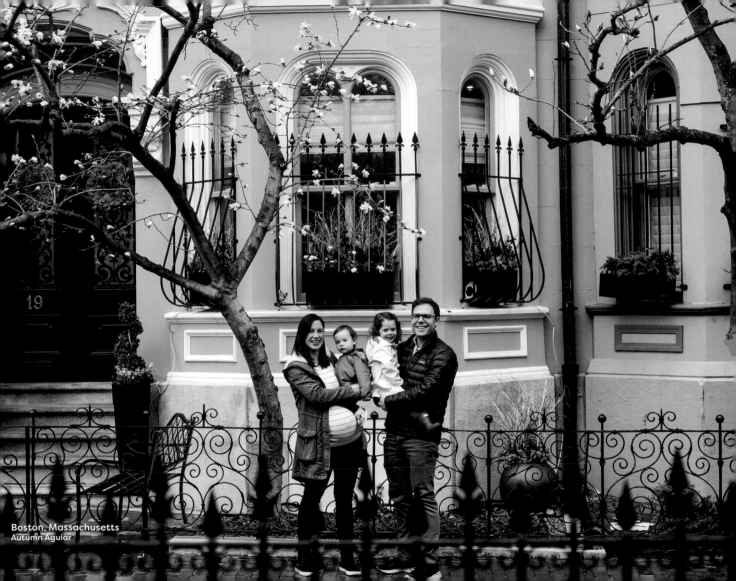

Boston, Massachusetts
Autumn Aguiar

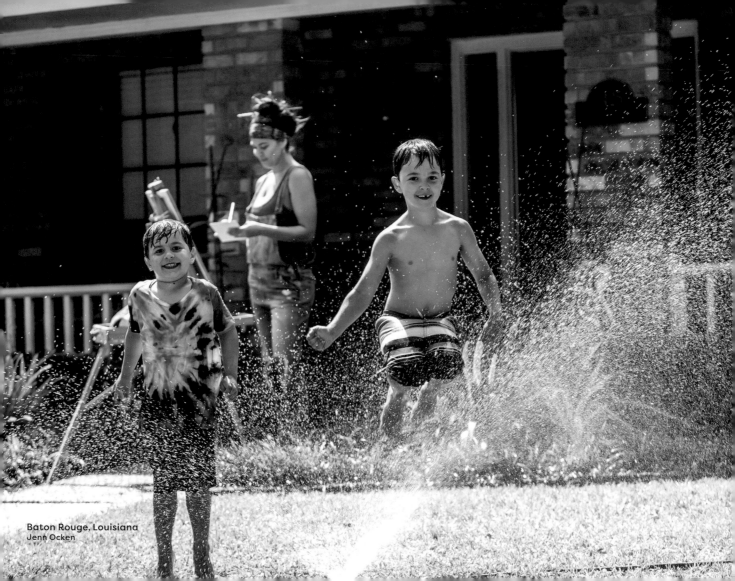

Baton Rouge, Louisiana
Jenn Ocken

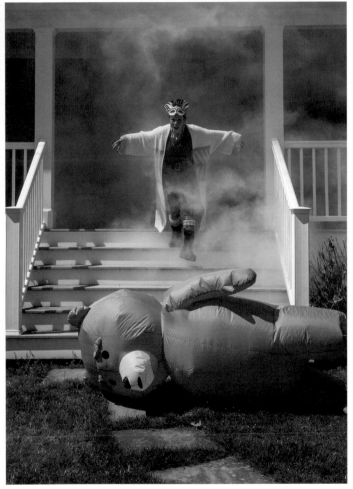

Old Greenwich, Connecticut

Danielle Coleman

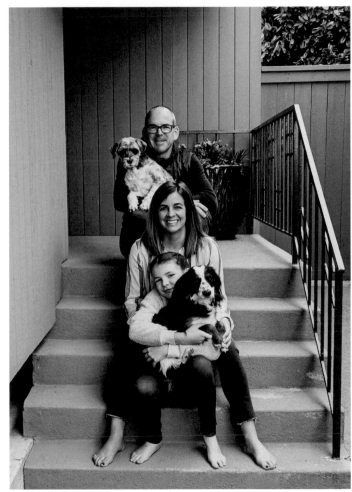

Seattle, Washington

Janet Maples

135

Alameda, California Stephanie Brand

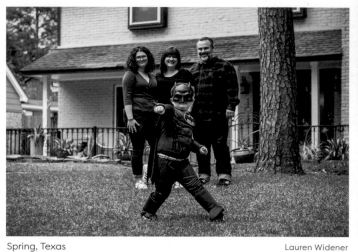

Spring, Texas Lauren Widener

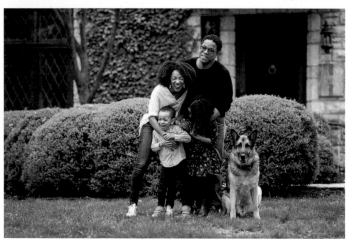

Columbus, Ohio Sarah Esposito

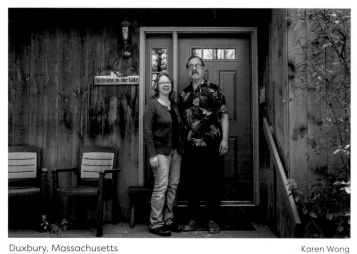

Duxbury, Massachusetts Karen Wong

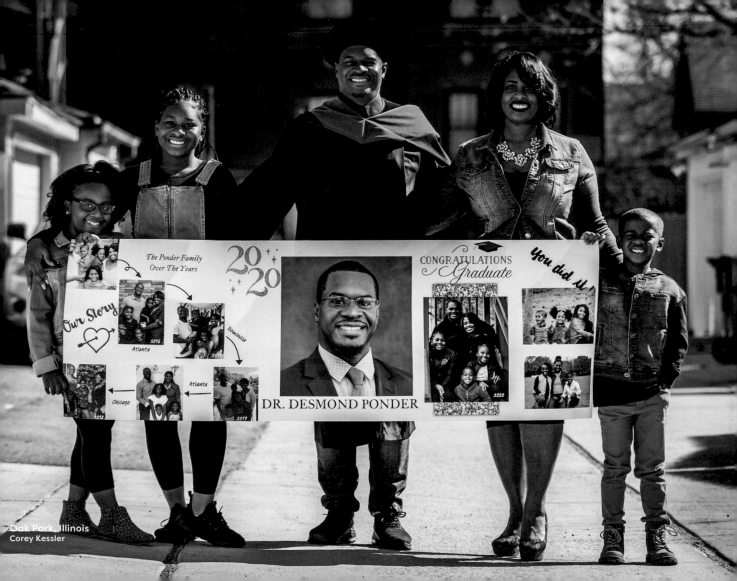

The Ponder Family
Over The Years

Our Story

2020

CONGRATULATIONS
Graduate

You did it!

Atlanta

Dominica

Atlanta

Chicago

2020

DR. DESMOND PONDER

Oak Park, Illinois
Corey Kessler

New Orleans, Louisiana
Jillian Carruth

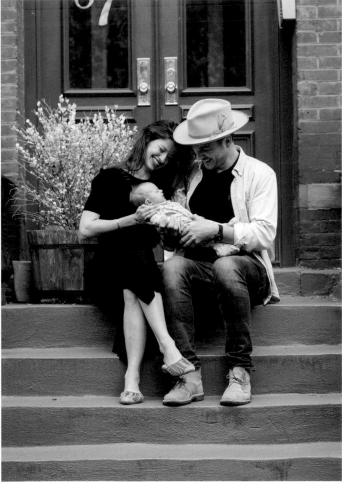

Brooklyn, New York Shrutti Garg

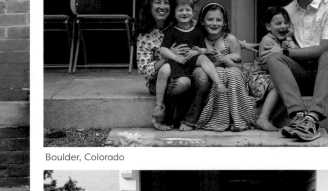

Boulder, Colorado Timolyn Esson

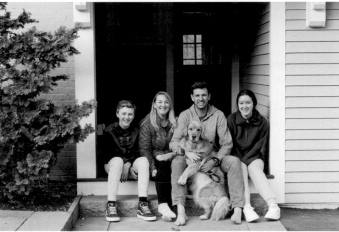

Needham, Massachusetts Cara Soulia

"The **JOY** that this project brought
to the families who participated
was so motivating and touching.
We loved seeing people in their natural
environment with no expectations
and no hidden agendas—just families
embracing the moment and
being real in front of our lenses."

Shari Fleming and Alexandra Crnobrna, Minnetonka, Minnesota

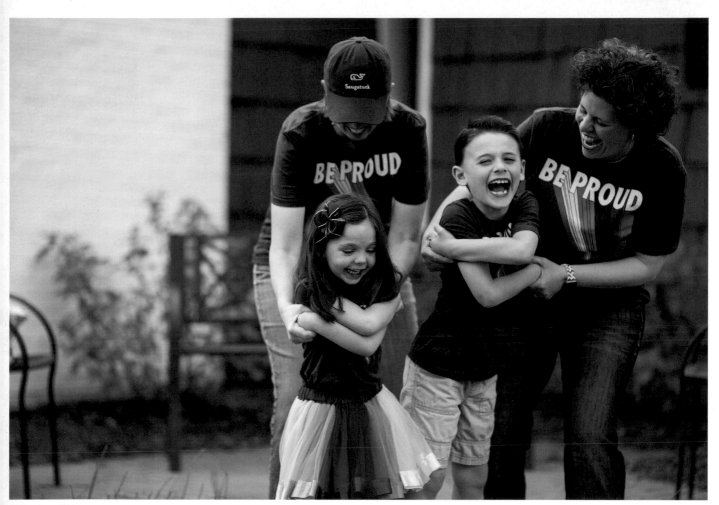

Columbus, Ohio

Sarah Esposito

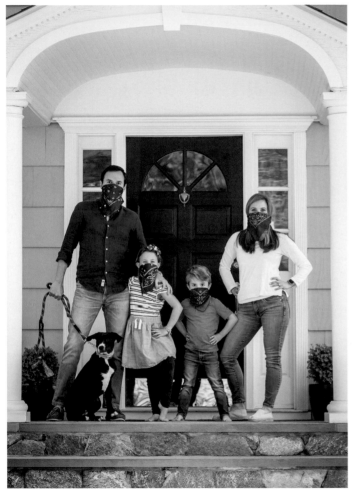

Wilton, Connecticut Xenia Gross

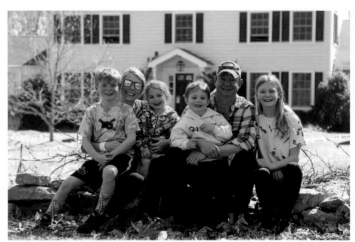

New Canaan, Connecticut Meghan Gould

Oakville, Ontario, Canada Sarah Sims

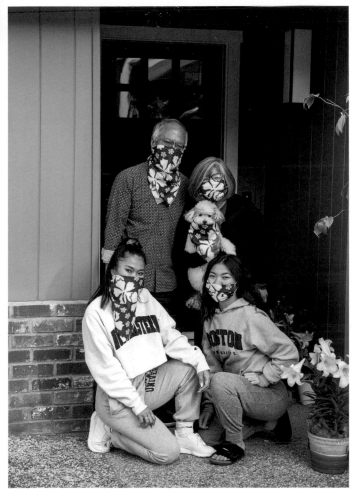

Greenbrae, California

Jen Skinner

Tampa, Florida

Amy Pezzicara

143

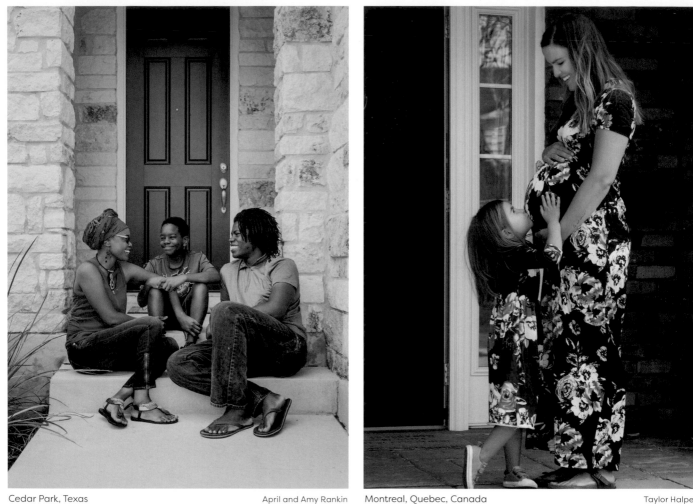

Cedar Park, Texas

April and Amy Rankin

Montreal, Quebec, Canada

Taylor Halperin

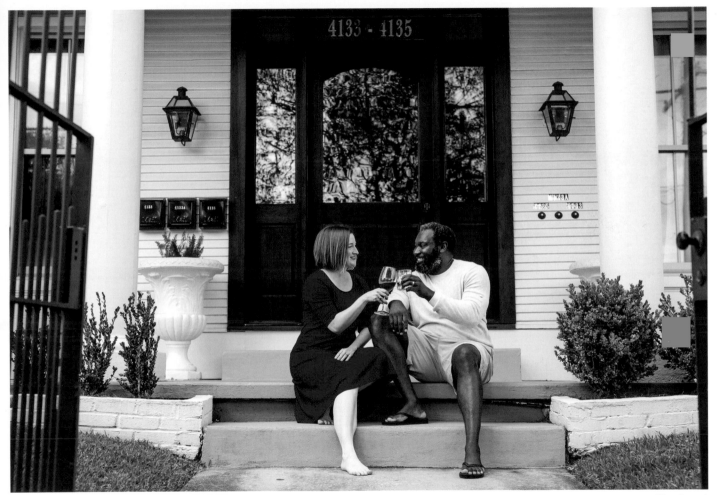

New Orleans, Louisiana

Jillian Carruth

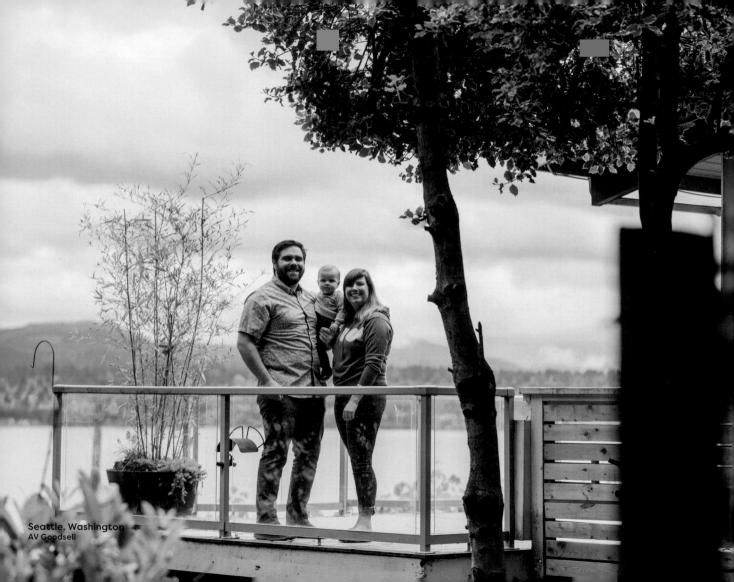

Seattle, Washington
AV Goodsell

Laguna Beach, California

Candice Dartez

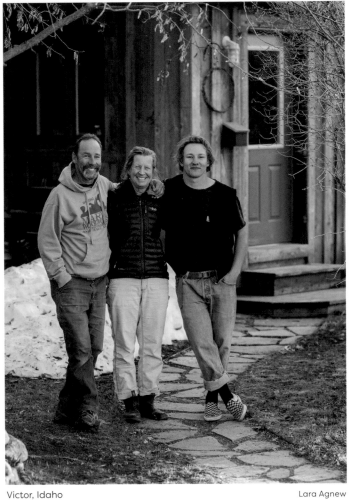

Victor, Idaho

Lara Agnew

" A woman offered to make a generous donation and pay my mileage if I would travel out of town to visit her uncle, who was recently diagnosed with a brain tumor. Even though I was exhausted from photographing over 200 families that month, something in my gut told me to make the time. Three days after the photo session, I received a message that the uncle had lost his battle. **Words can not explain the impact this will forever have on me.**

Leah Tyler-Szucki, Red Deer, Alberta, Canada

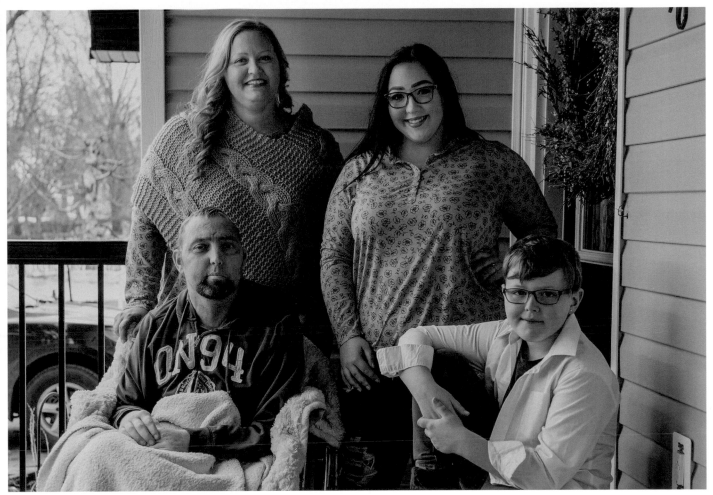

Red Deer, Alberta, Canada

Leah Tyler-Szucki

Kentfield, California
Jen Skinner

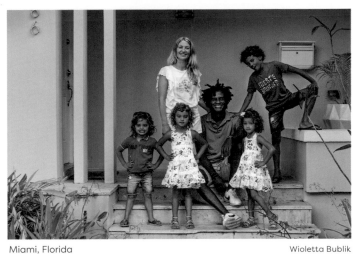

Hoboken, New Jersey Kim Gerlach

Miami, Florida Wioletta Bublik

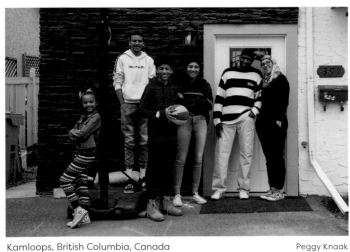

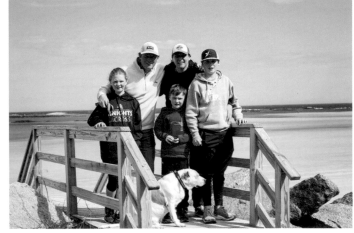

Kamloops, British Columbia, Canada Peggy Knaak

Kennebunkport, Maine Emily Ferrick

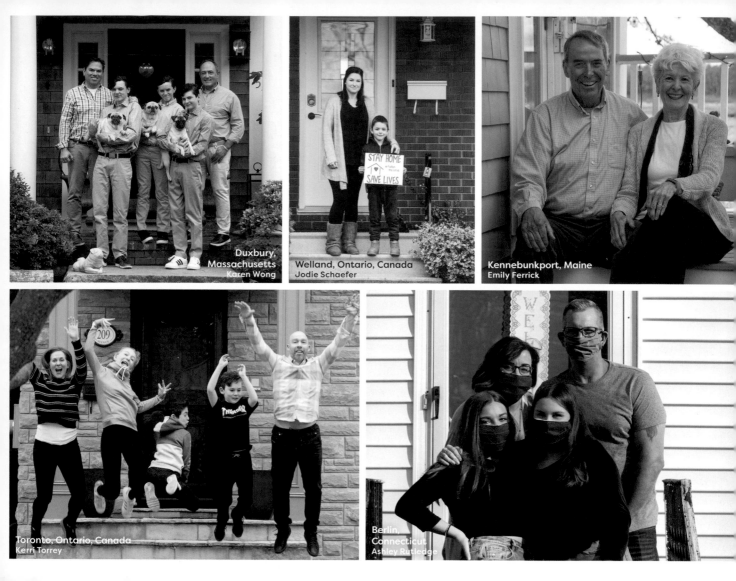

Duxbury, Massachusetts
Karen Wong

Welland, Ontario, Canada
Jodie Schaefer

STAY HOME
SAVE LIVES

Kennebunkport, Maine
Emily Ferrick

Toronto, Ontario, Canada
Kerri Torrey

Berlin, Connecticut
Ashley Rutledge

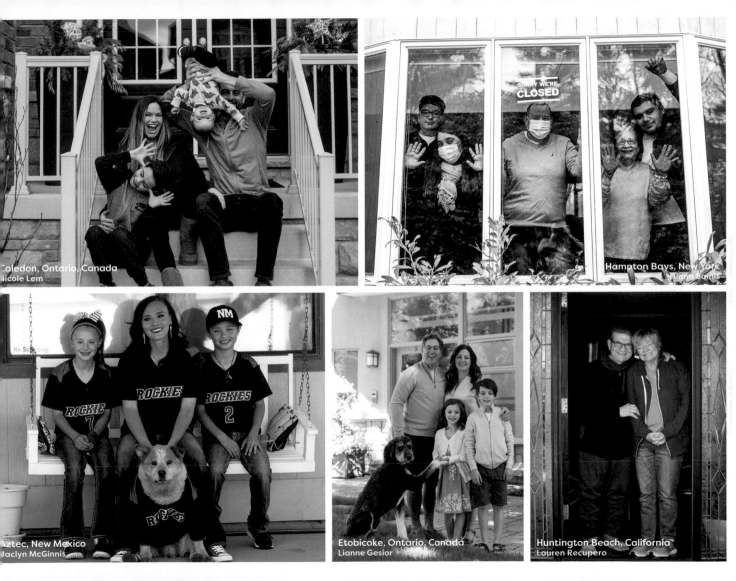

Caledon, Ontario, Canada
Nicole Lem

Hampton Bays, New York
Fiana Bains

Aztec, New Mexico
Jaclyn McGinnis

Etobicoke, Ontario, Canada
Lianne Gesior

Huntington Beach, California
Lauren Recupero

SORRY WE'RE CLOSED

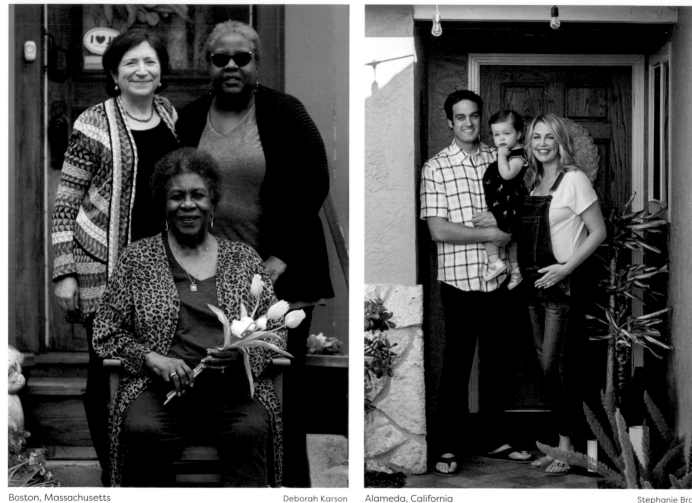

Boston, Massachusetts Deborah Karson

Alameda, California Stephanie Brand

Boulder, Colorado
Timolyn Esson

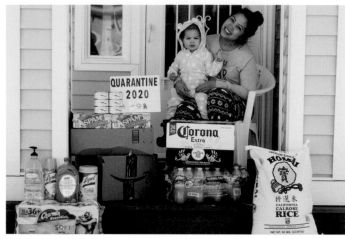

Fairbanks, Alaska Brittiney Blair

Milwaukee, Wisconsin Amber Parham

Cardrona, Scotland Becky Henderson

Baton Rouge, Louisiana Bambi Guthrie

Alexandria, Louisiana

Abigail Blalock

Seattle, Washington

AV Goodsell

Redmond, Oregon

Katie Hilt

Waterloo, Iowa

Kristin Chiasson

Needham, Massachusetts
Kate King

"From my side of the lens, it is clear that **COMPASSION** isn't hard to find. In March 2020, the world shut down. We were told to stay apart. Nevertheless, people found a way to come together. I will not soon forget the light of the people in the darkness."

Jodie Schaefer, Welland, Ontario, Canada

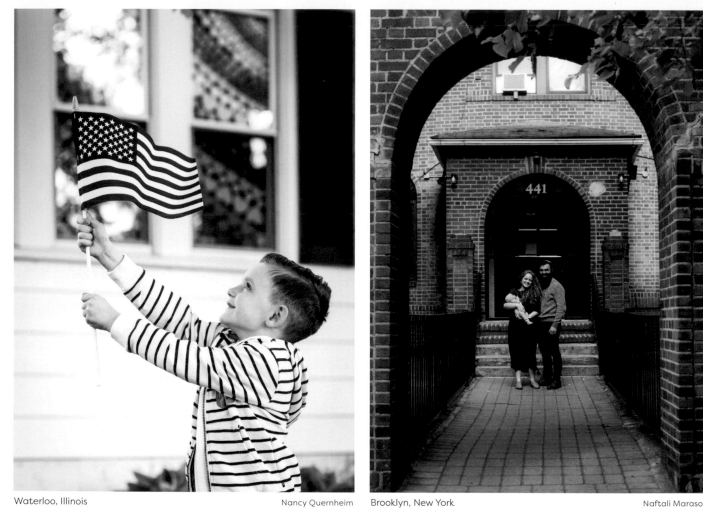

Waterloo, Illinois

Nancy Quernheim

Brooklyn, New York

Naftali Marasow

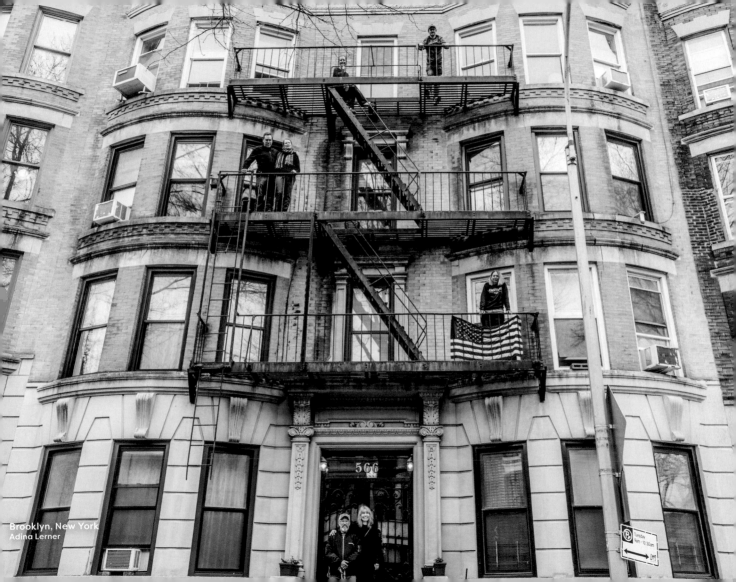

Brooklyn, New York
Adina Lerner

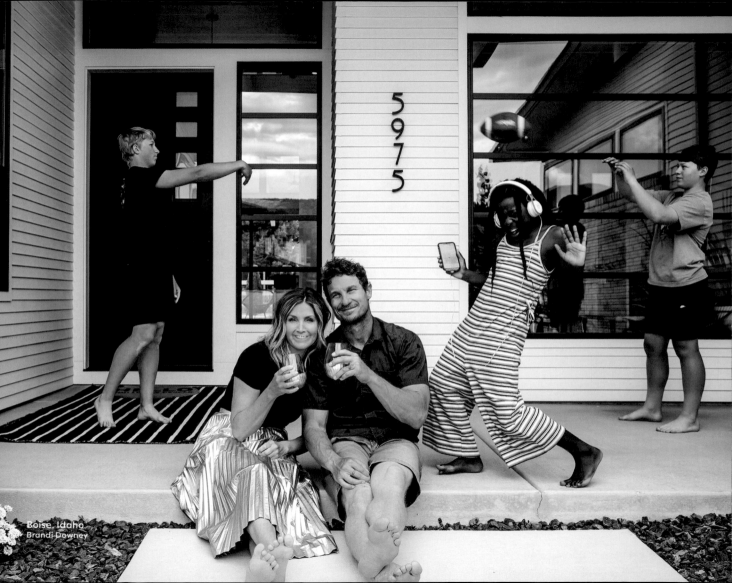

Boise, Idaho
Brandi Downey

Methuen, Massachusetts — Erin Marie

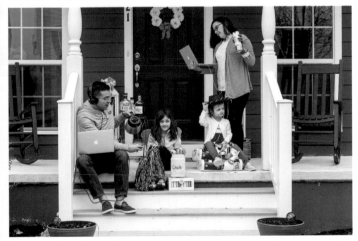

Mechanicsburg, Pennsylvania — Roger Baumgarten

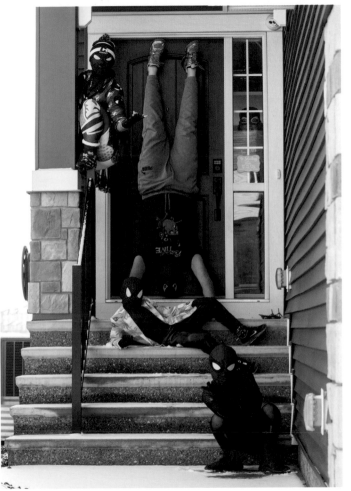

Calgary, Ontario, Canada — Erin Shepley

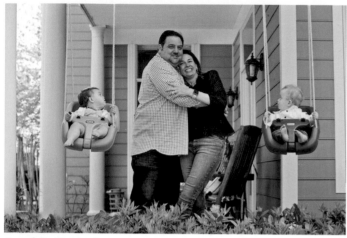

Annapolis, Maryland Amy Raab

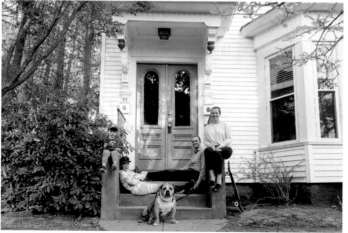

Needham, Massachusetts Cara Soulia

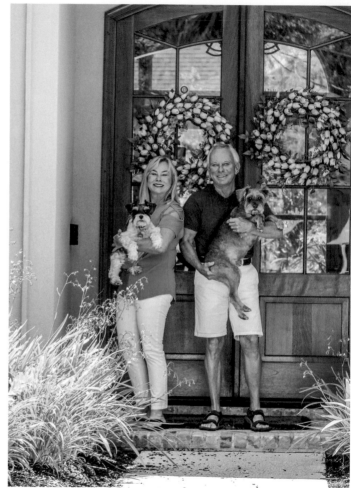

Mandeville, Louisiana Terri Parker

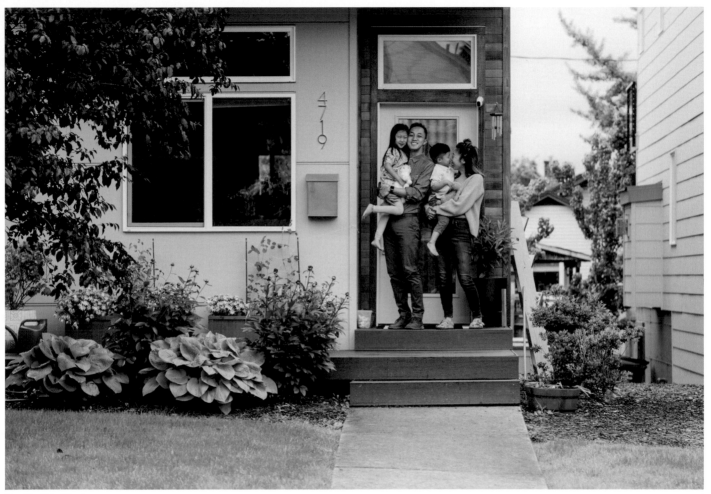

Seattle, Washington

AV Goodsell

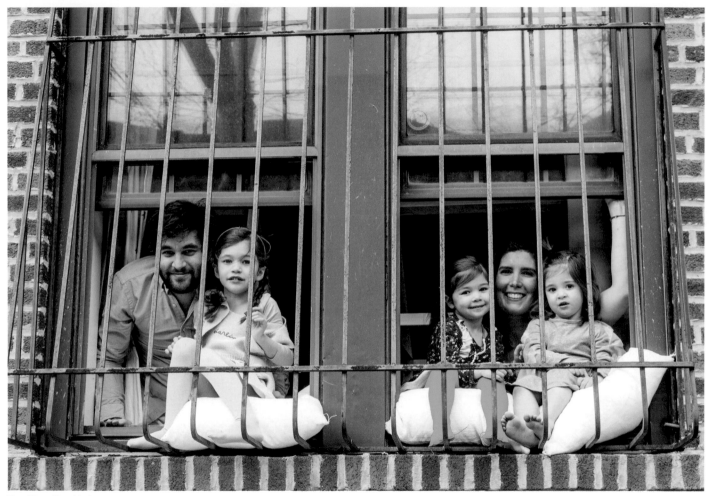

Brooklyn, New York

Adina Lerner

Columbus, Ohio

Erin Brown

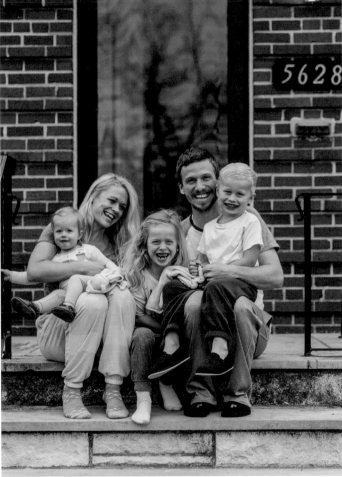

St. Louis, Missouri

Kelli Morrell

167

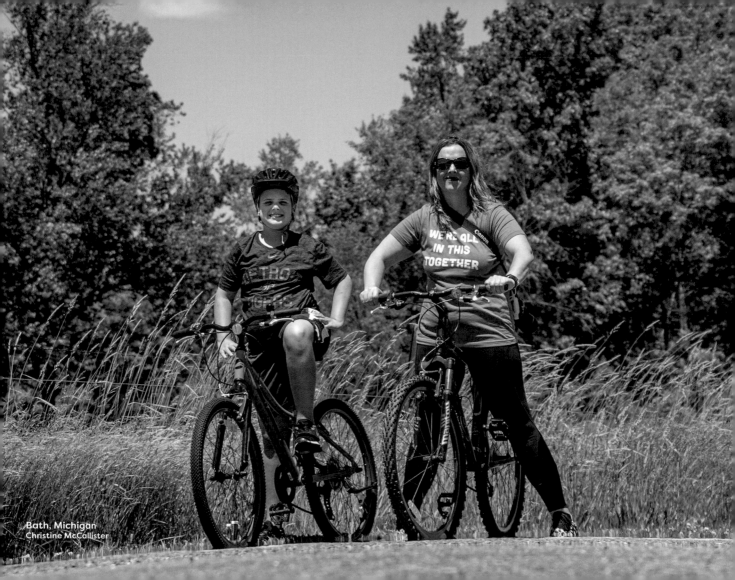

Bath, Michigan
Christine McCallister

" My 11-year-old son, Max, and I joined The Front Steps Project in mid-March. **We liked riding our bikes from house to house, which combined exercise, fresh air, and goodwill.** Max got to see faces of people he knew from afar, so he didn't feel so isolated. **We were able to take pictures of almost all the teachers in his school. There was a 32-day streak when we photographed at least one family per day!** I'm so glad Max got to see how easy it is to help others.

Christine McCallister, Bath, Michigan

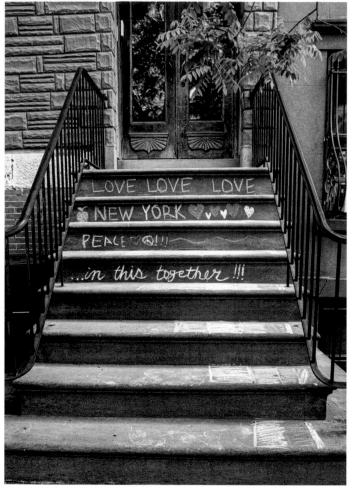

Brooklyn, New York Marj Kleinman

Calgary, Alberta, Canada Jennifer Krawchuk

River Forest, Illinois Steve Scheuring

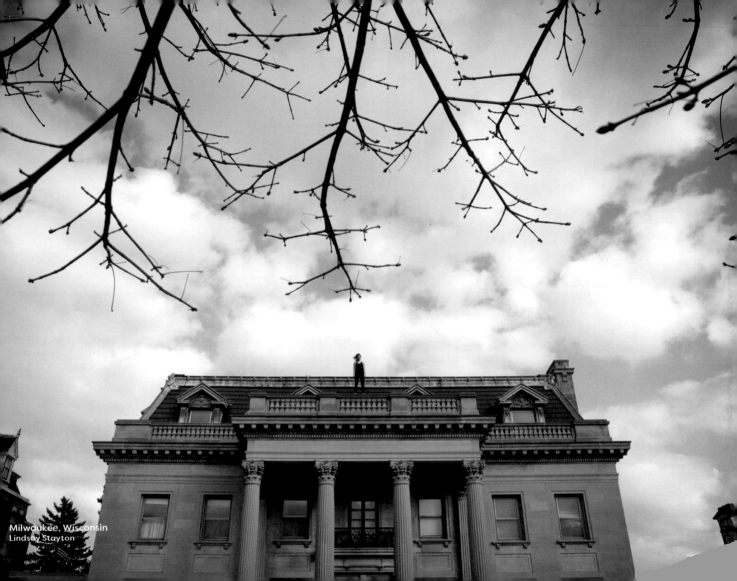

Milwaukee, Wisconsin
Lindsay Stayton

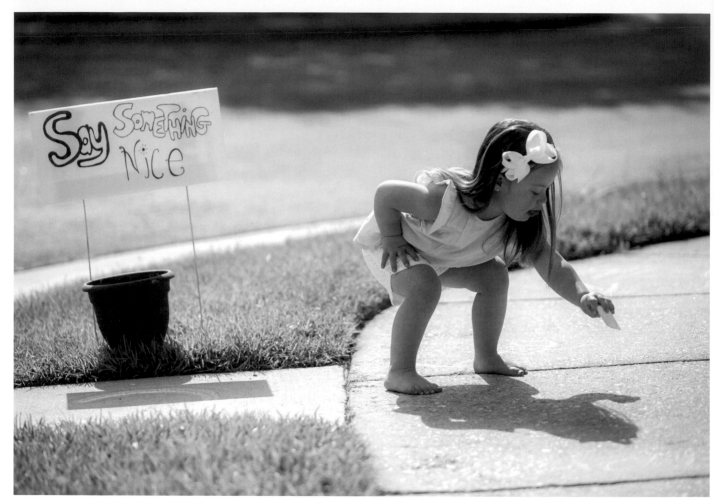

Baton Rouge, Louisiana

Jenn Ocken

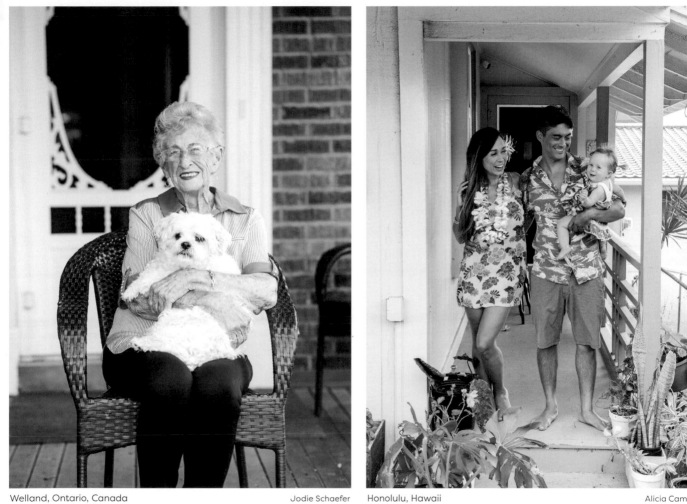

Welland, Ontario, Canada Jodie Schaefer Honolulu, Hawaii Alicia Camacho

Chappaqua, New York Randi Childs

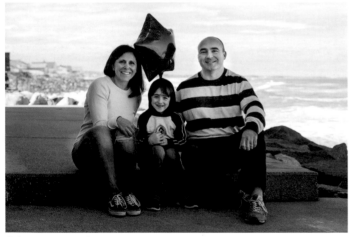

Cohasset, Massachusetts Lisa Gilbert

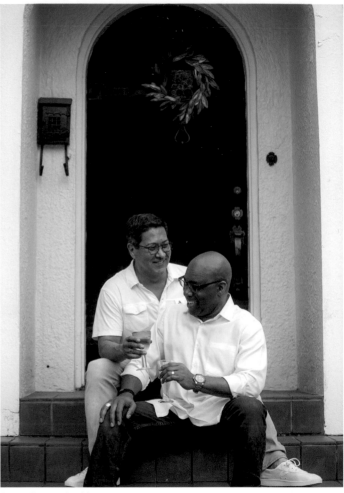

Baton Rouge, Louisiana Jenn Ocken

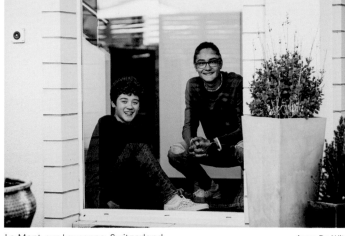

Le Mont-sur-Lausanne, Switzerland

Anna De Wit

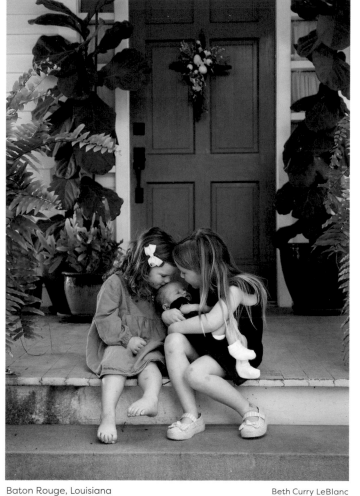

New Canaan, Connecticut

Andrea Chalon

Baton Rouge, Louisiana

Beth Curry LeBlanc

175

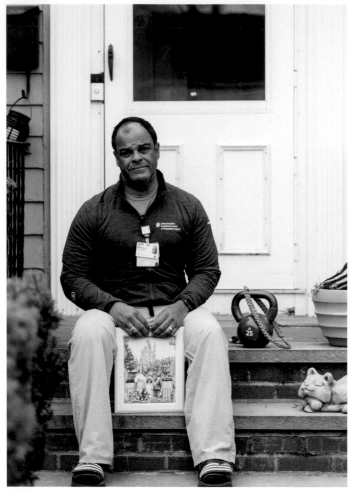

Milton, Massachusetts

Liz Mollica

"This gentleman told me the most powerful story. A military veteran and nurse practitioner, he chose to be photographed with an image of his wife and daughter. He told me: 'I miss my daughter Ally, who is no longer here. I miss my wife, as she is on the other side of the planet, [deployed] in Baghdad. I could just sink into nothingness, but **I want people in this world of pain and suffering to know that I care.'**

Liz Mollica, Quincy, Massachusetts

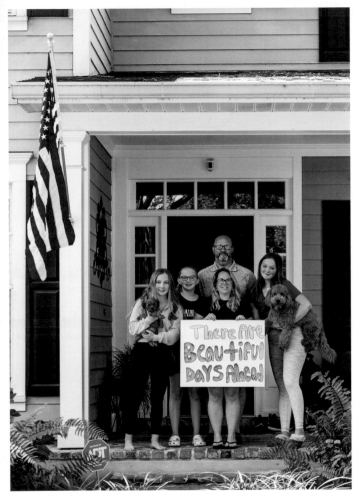

Tampa, Florida

Amy Pezzicara

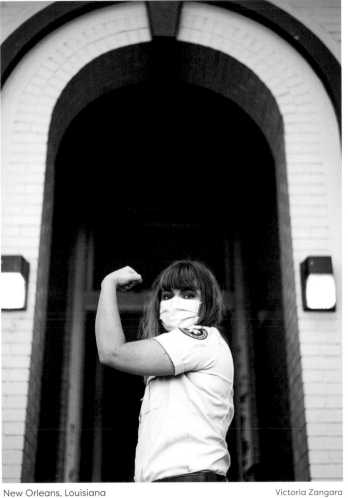

New Orleans, Louisiana

Victoria Zangara

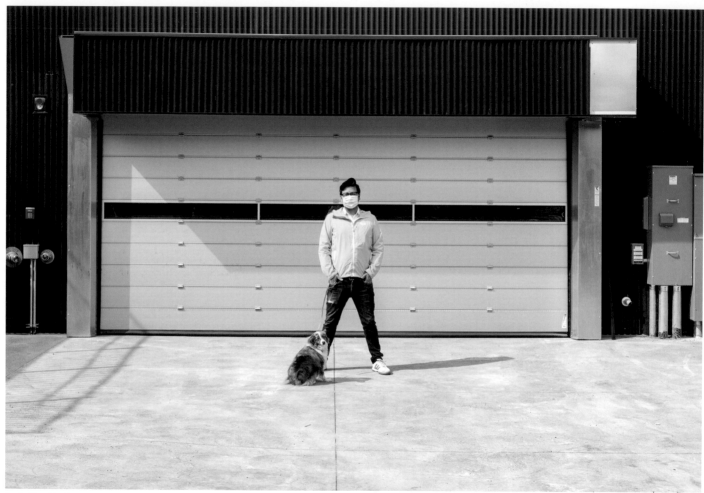

Park City, Utah

Matthew Davis

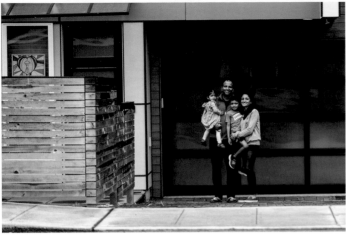

Seattle, Washington AV Goodsell

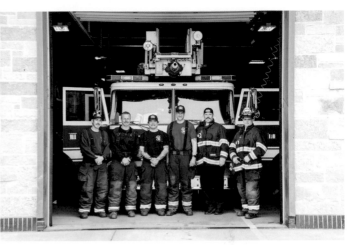

Milwaukee, Wisconsin Amber Parham

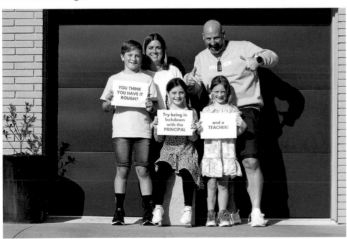

Tauranga, New Zealand Alisha and Mike Taylor

Driggs, Idaho Lara Agnew

179

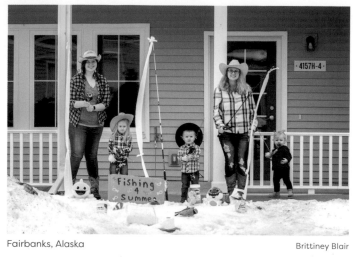

Fairbanks, Alaska Brittiney Blair

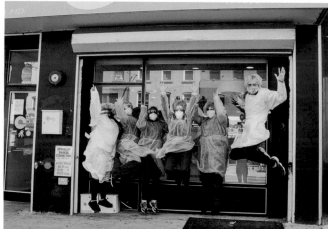

Brooklyn, New York Shrutti Garg

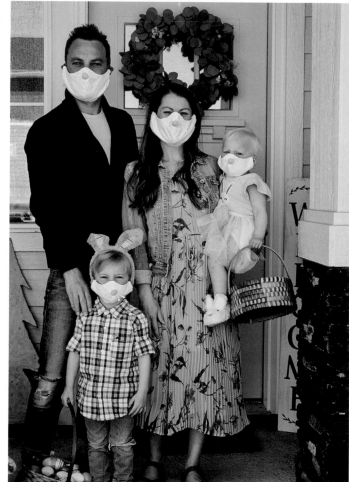

Boise, Idaho Taylor Badzic

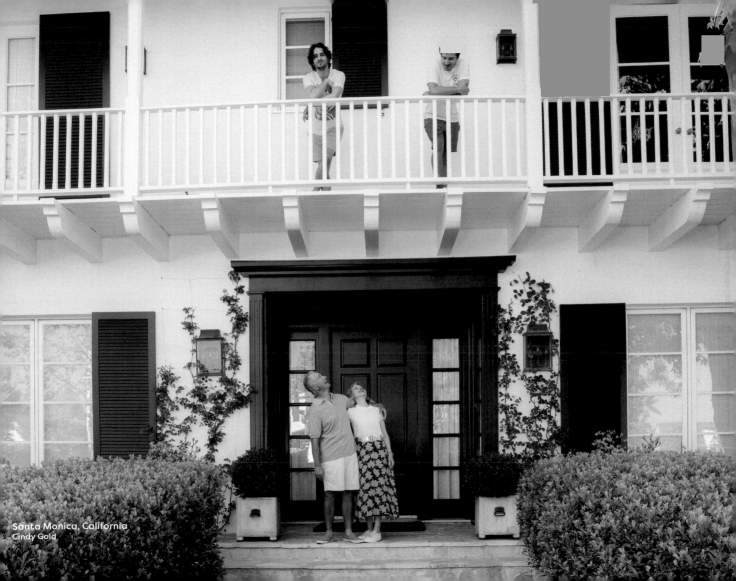

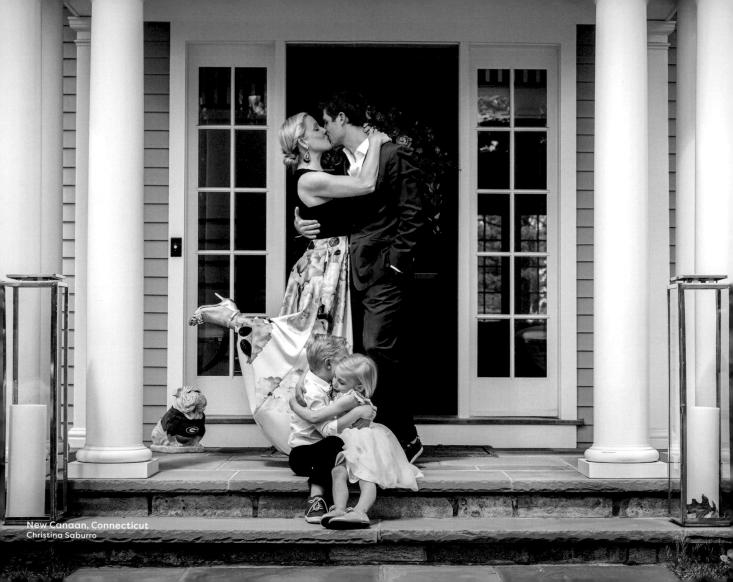

New Canaan, Connecticut
Christina Saburro

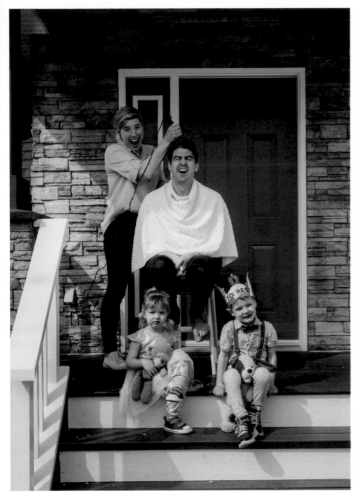

Vancouver, British Columbia, Canada — Laura-Lee Gerwing

Kingston, Jamaica — Marina Burnel

"Someday I hope to host a block party for the families I met to strengthen the bond we made through the photo sessions. In light of the recent struggles in our world, this project is a priceless gift! It fills me with so much **PRIDE** to be part of it."

Lauren Widener, Spring, Texas

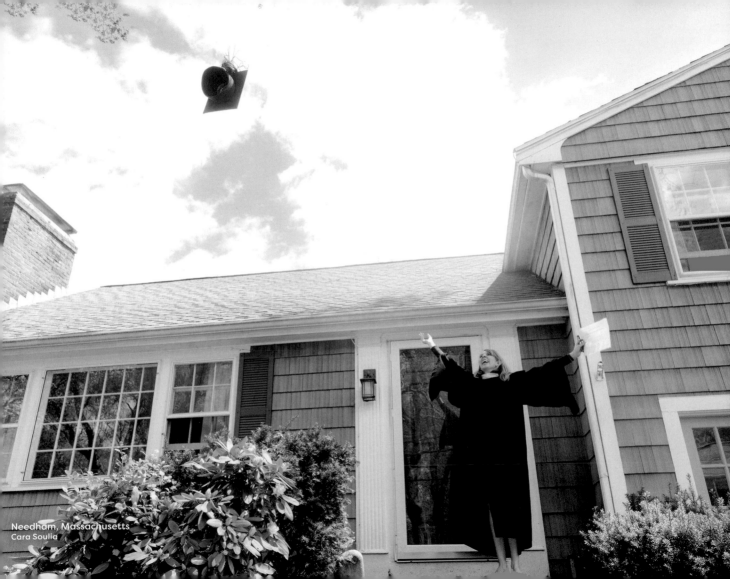

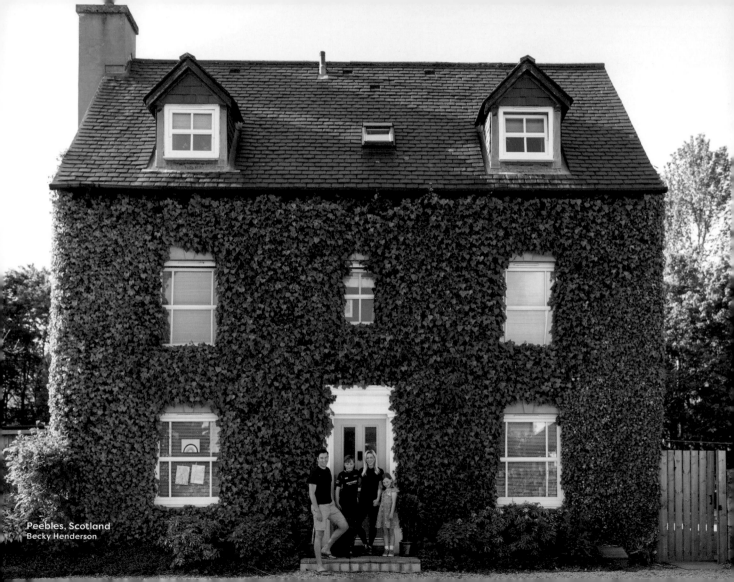

Peebles, Scotland
Becky Henderson

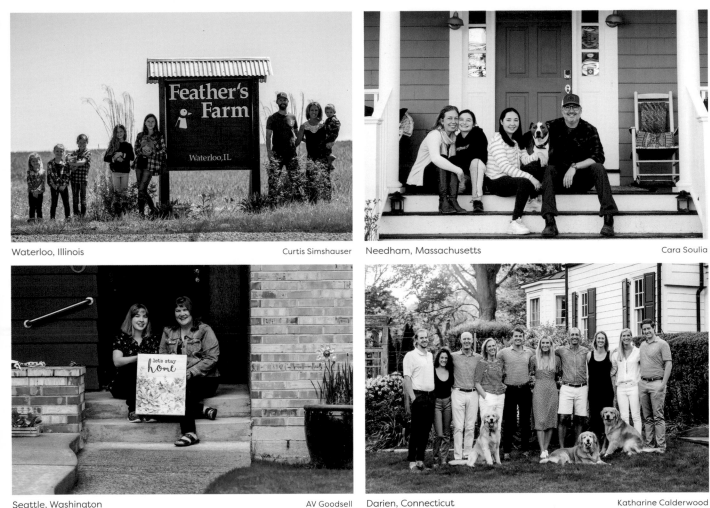

Waterloo, Illinois — Curtis Simshauser

Needham, Massachusetts — Cara Soulia

Seattle, Washington — AV Goodsell

Darien, Connecticut — Katharine Calderwood

Albuquerque, New Mexico
Alison Hatch

Toronto, Ontario, Canada
Kerri Torrey

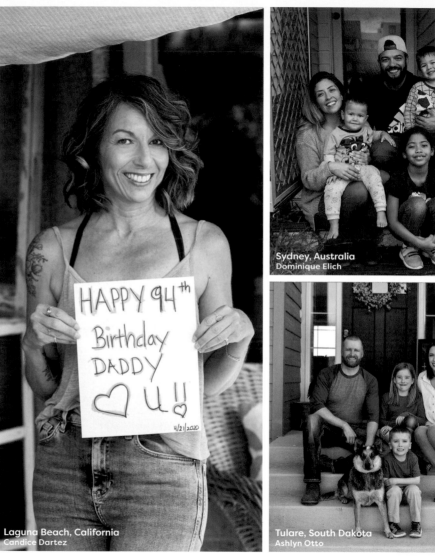

Sydney, Australia
Dominique Elich

HAPPY 94th
Birthday
DADDY
♡ U !!
4/21/2020

Laguna Beach, California
Candice Dartez

Tulare, South Dakota
Ashlyn Otto

Pointe-Claire, Quebec, Canada
Sophy Hurtubise

Chesapeake, Virginia
Melinda Hogaboom

Cary, North Carolina
Gregory Ng

Miami, Florida
Violetta Bublik

Santa Barbara, California
Aurielle Whitmore

Santa Monica, California
Cindy Gold

Cape Town, South Africa Brenda Veldtman

Santa Monica, California Cindy Gold

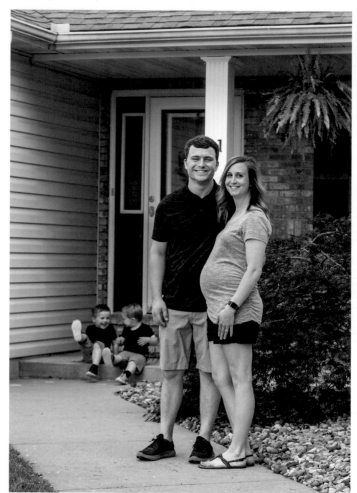

Waterloo, Illinois Emilie Newbury

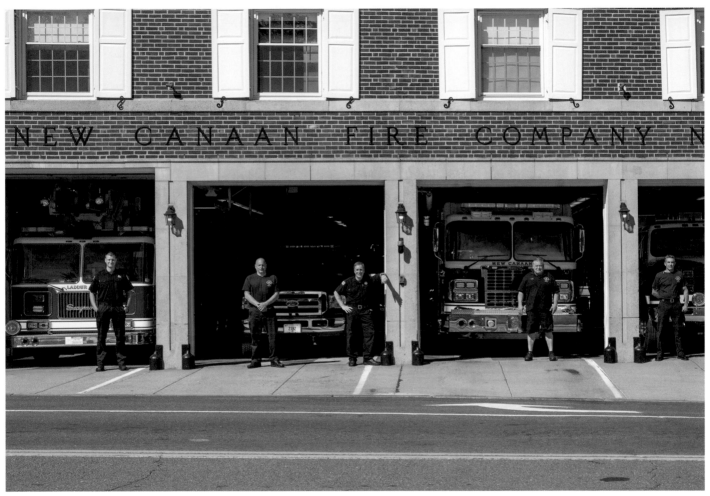

New Canaan, Connecticut

Andrea Ceraso

Oakbank, Manitoba, Canada — Ashley Stevens

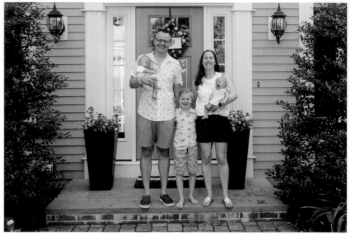

Needham, Massachusetts — Cara Soulia

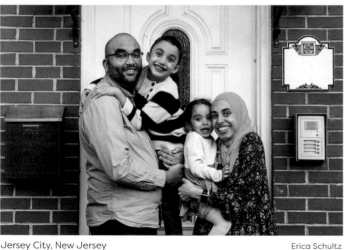

Jersey City, New Jersey — Erica Schultz

Port Allen, Louisiana — Davis Hotard

CONGRATS XAVIER 2020

Spring, Texas
Lauren Widener

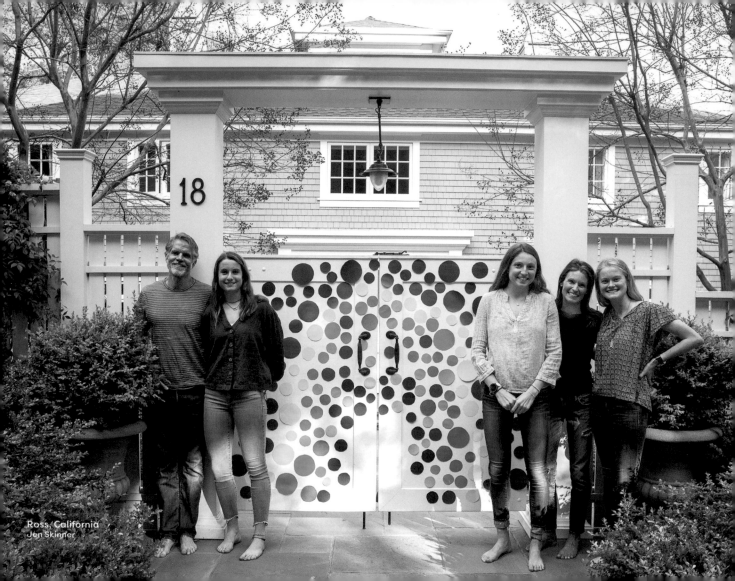

Ross, California
Jen Skinner

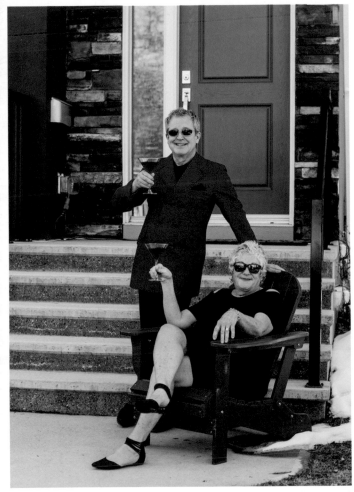

Calgary, Alberta, Canada

Jennifer Krawchuk

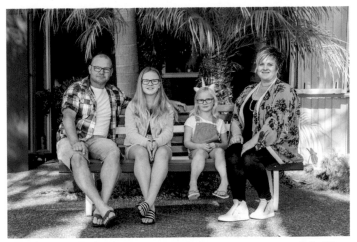

Tauranga, New Zealand

Kelly O'Hara

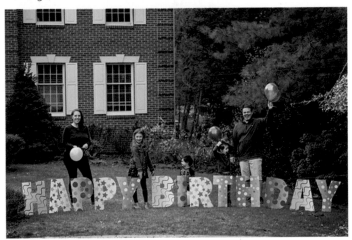

Allendale, New Jersey

Kim DeGooyer

195

Los Angeles, California

Carina Miller

"One image that jumps out is of a single mom with a severely autistic son. She was so apologetic. Finally, there was a quiet moment when her son settled down and **the light was beautiful and the atmosphere was eerily quiet— and there was just love.**"

Carina Miller, Los Angeles, California

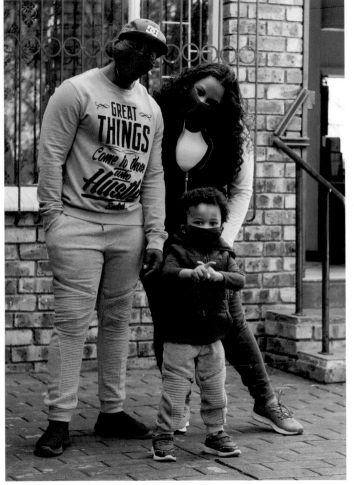

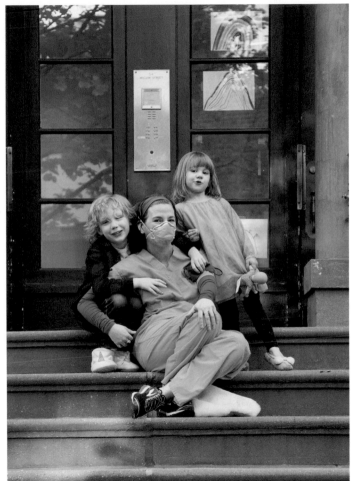

Pretoria, Gauteng, South Africa Corlia Bredell

Brooklyn, New York Vanessa Ryan

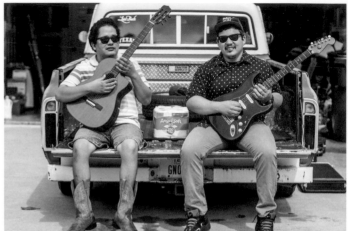

Lockhart, Texas — April and Amy Rankin

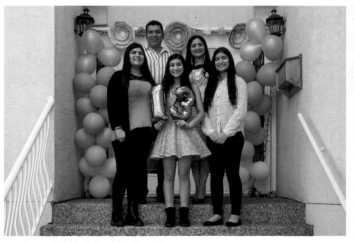

Tauranga, New Zealand — Alisha and Mike Taylor

Kamloops, British Columbia, Canada — Peggy Knaak

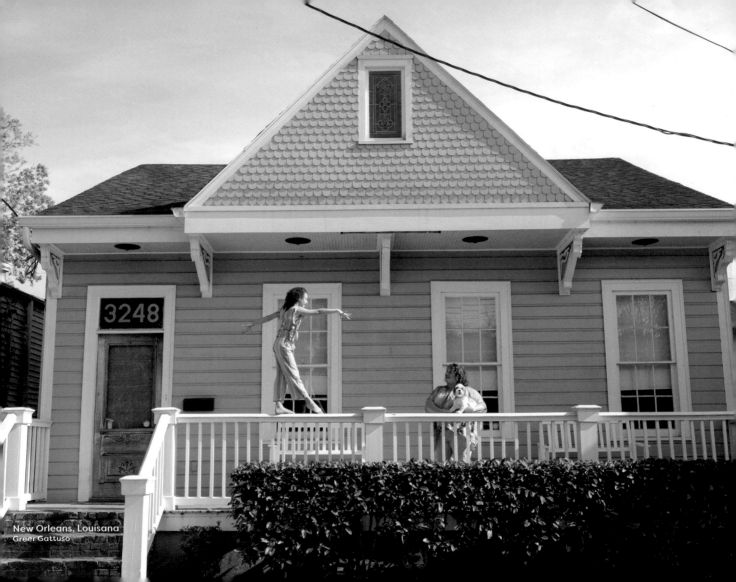

3248

New Orleans, Louisana
Greer Gattuso

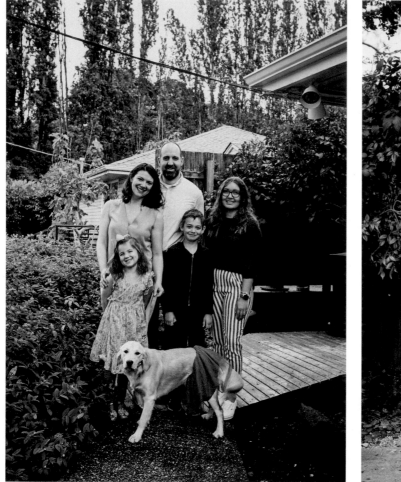

Seattle, Washington

Janet Maples

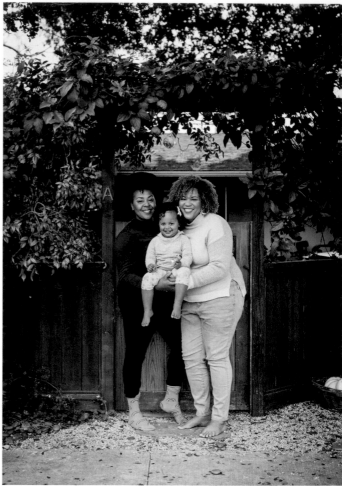

Santa Barbara, California

Aurielle Whitmore

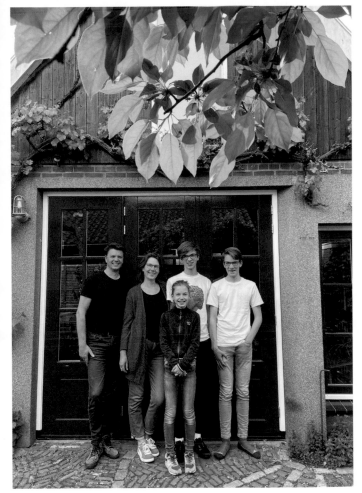

Lochem, The Netherlands

Lonetta Toussaint

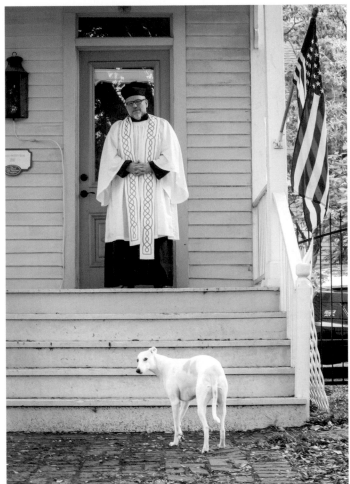

Baton Rouge, Louisiana

Jenn Ocken

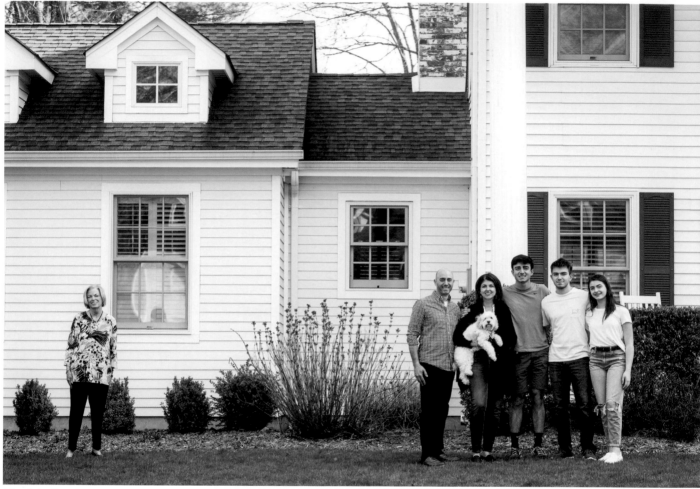

Allendale, New Jersey

Kim DeGooyer

"One day I had an opportunity to photograph some good friends, a couple and their three children. Their grandmother lives in a condo about a half-mile away and leaving her out was not an option. Though they couldn't stand together physically, we worked together on a way to keep their Ma in the picture. **Even though she was socially distanced, the image is poignant, depicting the real challenges that families have during this time.**

Kim DeGooyer, Allendale, New Jersey

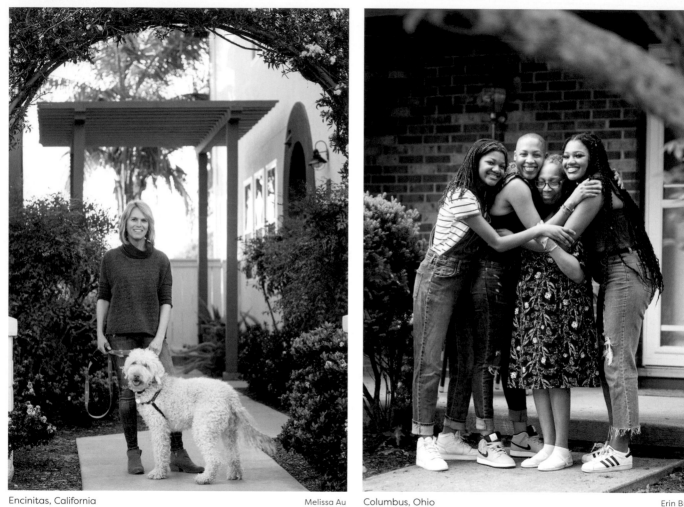

Encinitas, California — Melissa Au

Columbus, Ohio — Erin Brown

Portland, Oregon
Jeanette Schenk

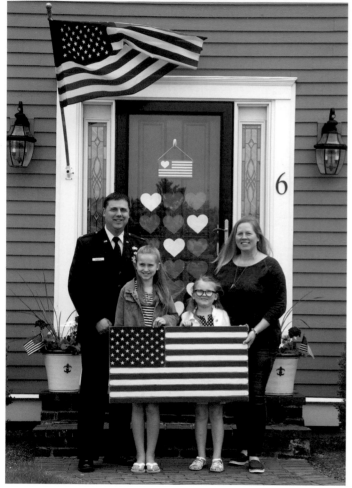

Duxbury, Massachusetts

Karen Wong

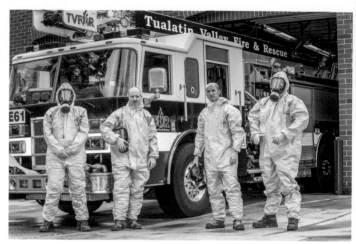

Beaverton, Oregon

Jeanette Schenk

Daniel Island, South Carolina

Tiffany Mizzell

Dublin, Ireland Maria Rusk

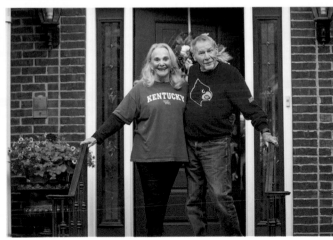

Louisville, Kentucky Kate Vogel

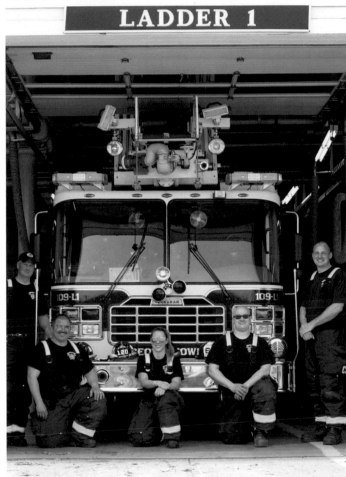

Georgetown, Massachusetts Becca O'Malley

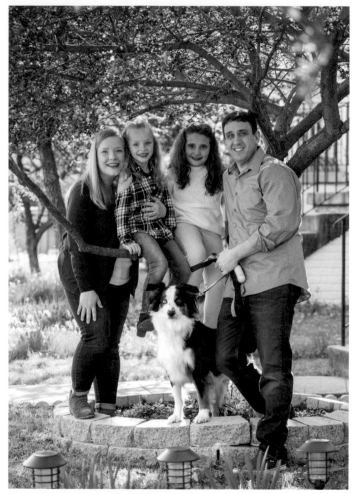

Charles Town, West Virginia Julie Roggenkamp

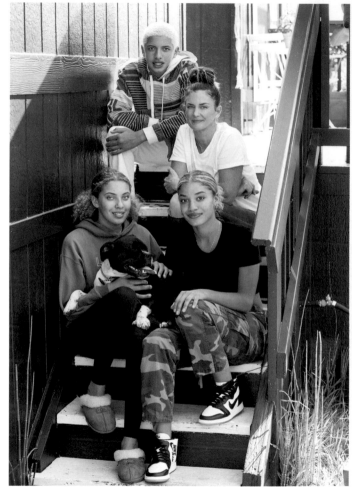

Laguna Beach, California Candice Dartez

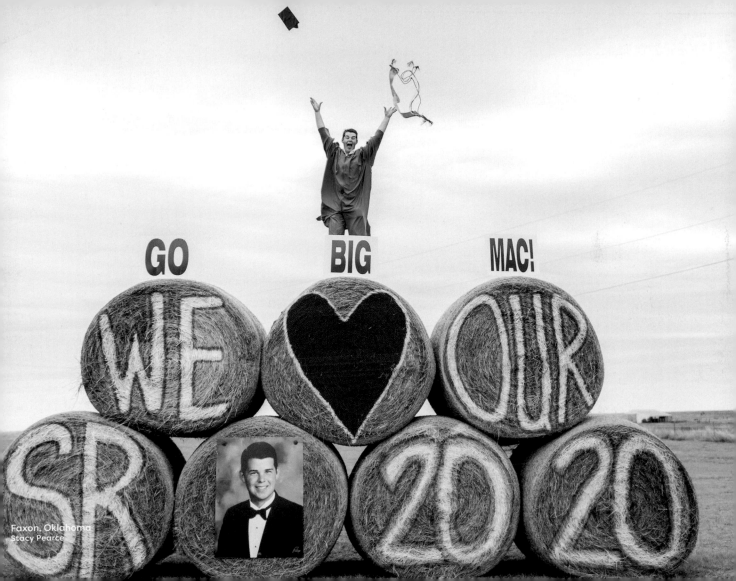

GO BIG MAC!

WE ♥ OUR SR 2020

Faxon, Oklahoma
Stacy Pearce

Mooresville, North Carolina
Kathleen and Ed Martin

"As a non-practicing nurse and now photographer, it was my calling and mission to recognize my fellow medical professionals and frontliners. These photos showcase their **SACRIFICE** and reveal what they do everyday to help save lives."

Jennisse Uy, Union City, New Jersey

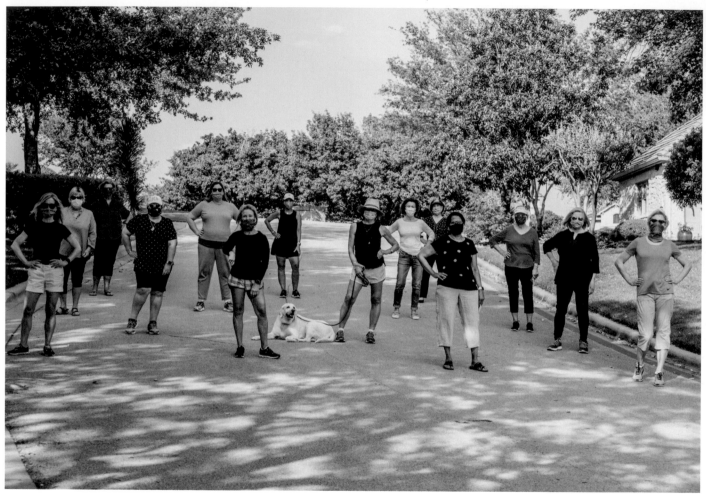

Austin, Texas

April and Amy Rankin

New Orleans, Louisiana Brittany Develle

Pelham, Massachusetts Isabella Dellolio

Brighton, Michigan

Kelly Stork

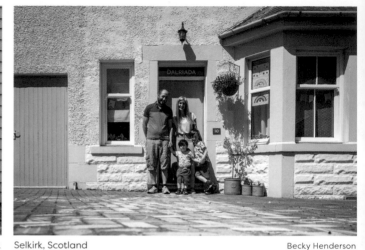

Selkirk, Scotland

Becky Henderson

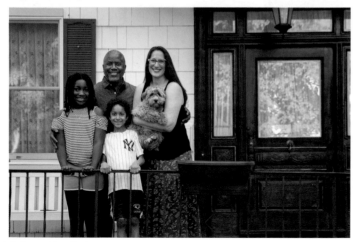

Pelham, New York

Jaye McLaughlin

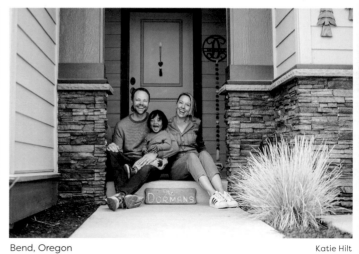

Bend, Oregon

Katie Hilt

West Roxbury, Massachusetts

Jaymie McManus

"These are my family friends. I am an eighth grader at Boston Latin Academy. **I raised $3,000** doing The Front Steps Project then used the money **to buy meals for frontline and healthcare workers.**"

Jaymie McManus, West Roxbury, Massachusetts

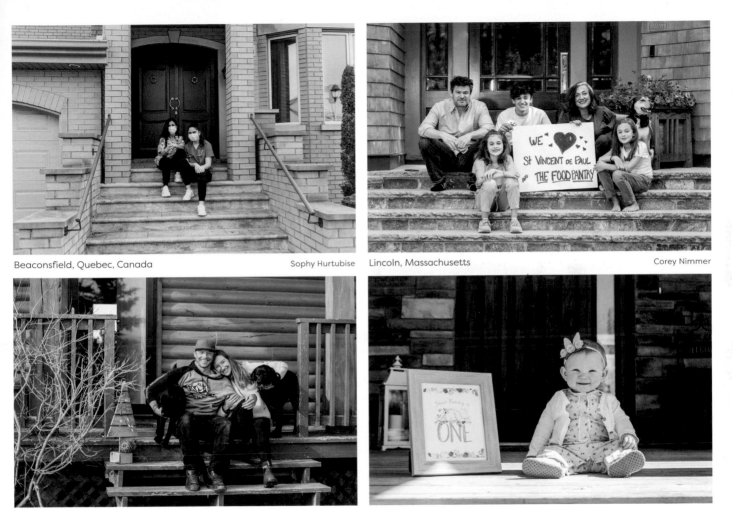

Beaconsfield, Quebec, Canada — Sophy Hurtubise

Lincoln, Massachusetts — Corey Nimmer

WE ♥ St VINCENT DE PAUL AND THE FOOD PANTRY

Victor, Idaho — Lara Agnew

Stonewall, Manitoba, Canada — Teesha Hall

ONE

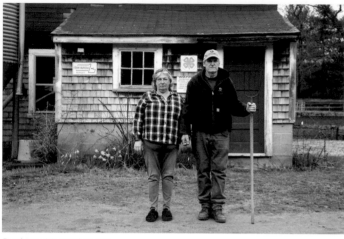

Duxbury, Massachusetts

Karen Wong

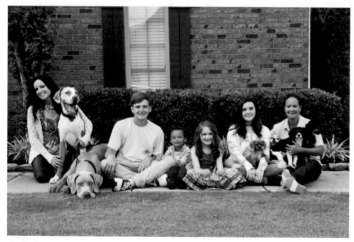

Corinth, Mississippi

Lisa Lambert

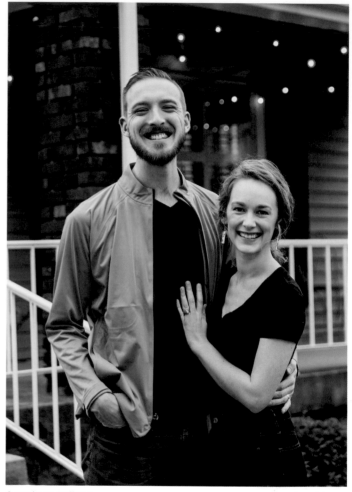

Speedway, Indiana

Lane Warner

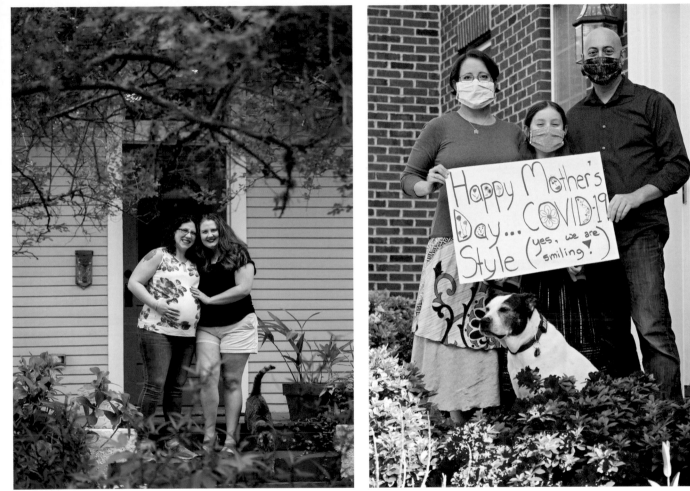

The sign reads: "Happy Mother's Day... COVID-19 Style (yes, we are smiling!)"

Baton Rouge, Louisiana Jenn Ocken

Crofton, Maryland Amy Raab

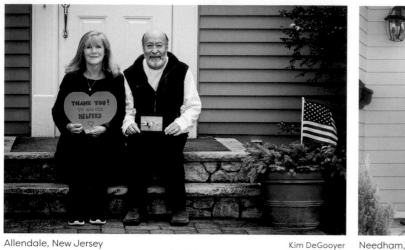

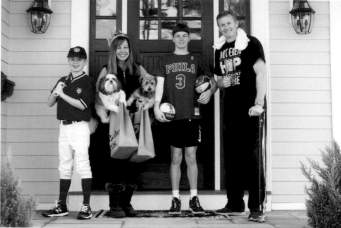

Allendale, New Jersey Kim DeGooyer

Needham, Massachusetts Caitrin Dunphy

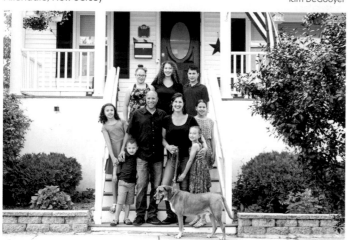

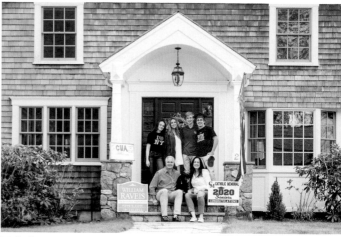

Medford, Massachusetts Christina Mendonca

Wellesley, Massachusetts Helena Goessens

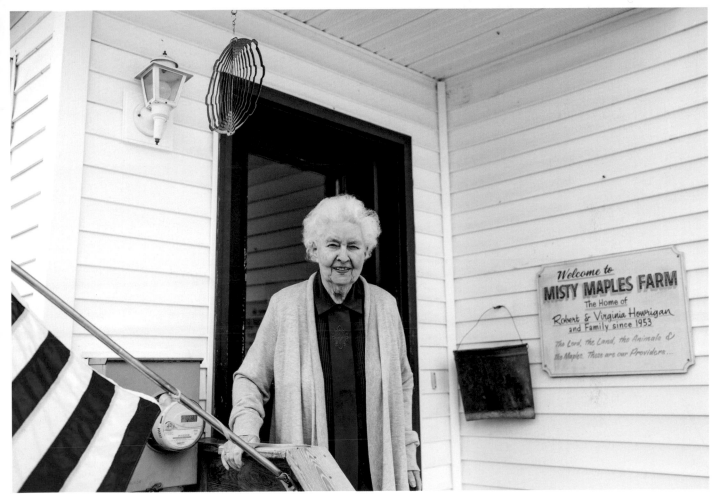

Fairfield, Vermont

Ellen Sargent

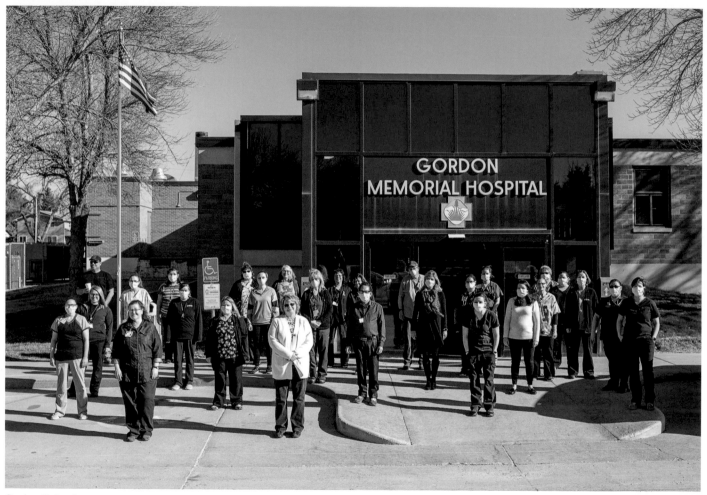

Gordon, Nebraska

Chelsie Moreland

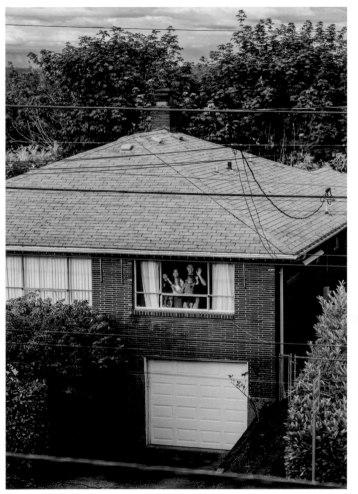

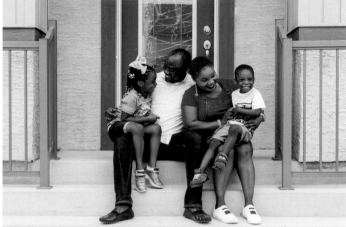

Winnipeg, Manitoba, Canada — Mary-Margaret Magyar

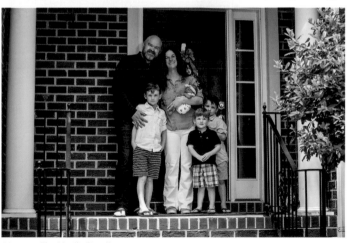

Mooresville, North Carolina — Kathleen and Ed Martin

Seattle, Washington — AV Goodsell

Mooresville, North Carolina
Kathleen and Ed Martin

"With every photo, there was a story that ran so much deeper than the quick flash of smiles: lost jobs and canceled vacations; nervous parents and bored kids; new activities and rediscovered interests. We photographed a state trooper, ER doctors, nurses, physicians, and teachers...

We met newborn babies and newly adopted puppies. We congratulated graduates and celebrated birthdays.

We took more than 7,700 photos and raised more than $50,000 for charity. **We will forever treasure meeting all the people!**

Kathleen and Ed Martin, Mooresville, North Carolina

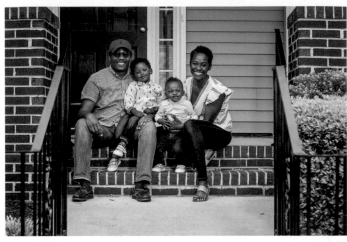

Mooresville, North Carolina — Kathleen and Ed Martin

"When we started this project, **we had no idea how much happiness it would bring to everyone we met.** We miss it more than we would have imagined."

Kathleen and Ed Martin,
Mooresville, North Carolina

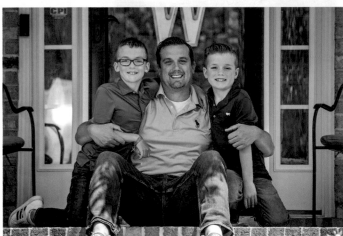

Mooresville, North Carolina — Kathleen and Ed Martin

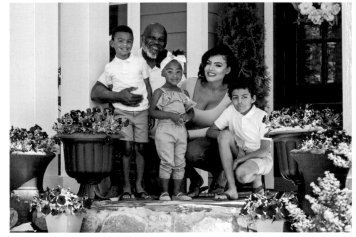

Mooresville, North Carolina — Kathleen and Ed Martin

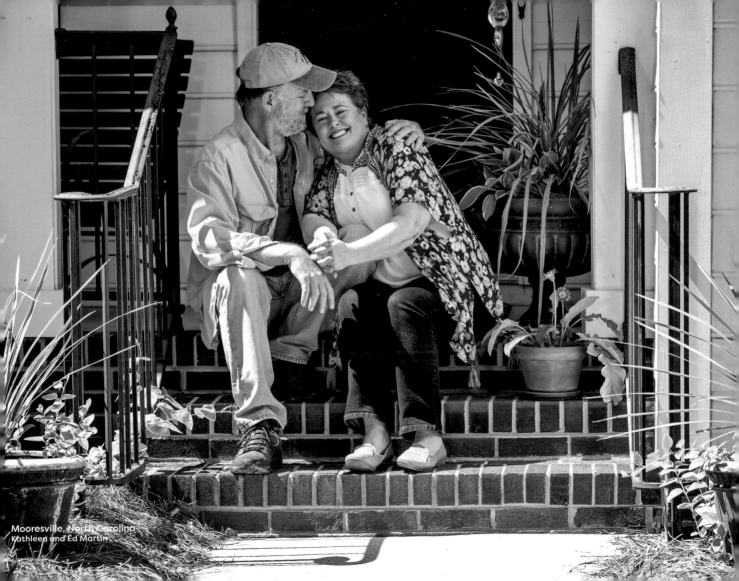

Mooresville, North Carolina
Kathleen and Ed Martin

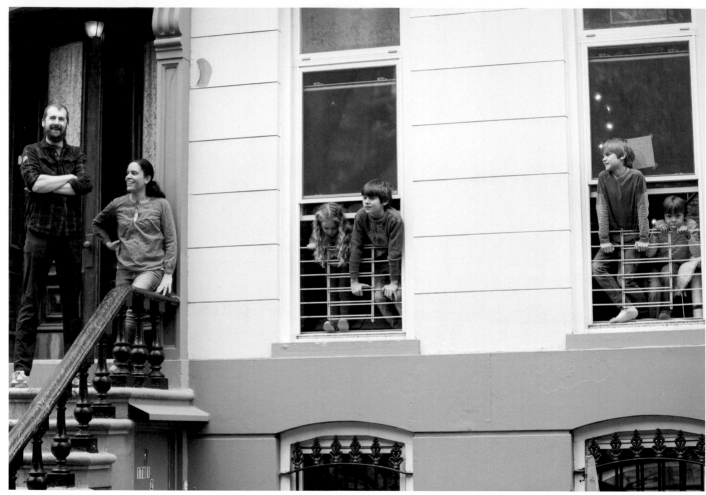

Brooklyn, New York

Marc Goldberg

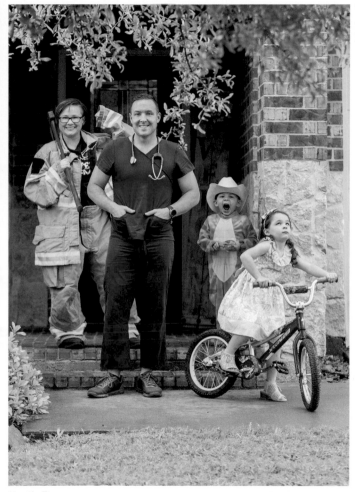

Heath, Texas

Destiny Wanamaker

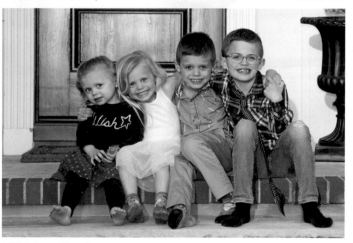

Hoboken, New Jersey

Kim Gerlach

Middletown, New Jersey

Martha Dement

"Armed with my camera, I showed the families of my community that we weren't going to be beaten down by the illness. Even though it has separated us physically, we were still together. Our **PERSEVERANCE** was tested, and we were socially isolated, but we remained emotionally bonded."

Alison Hatch, Albuquerque, New Mexico

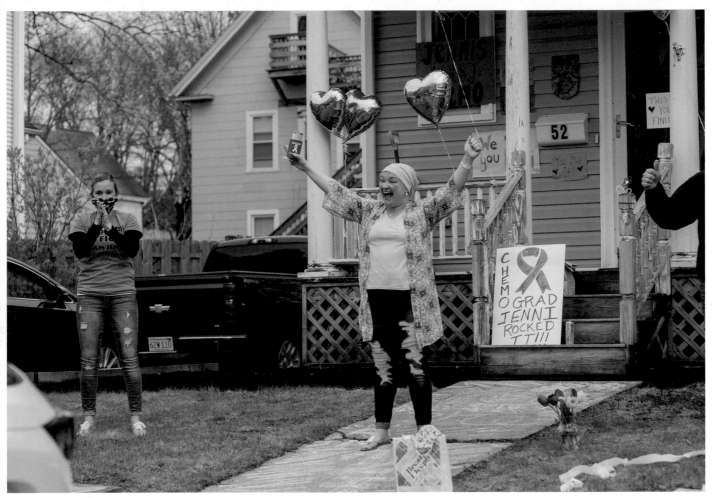

Rockland, Massachusetts

Rebecca Deaton

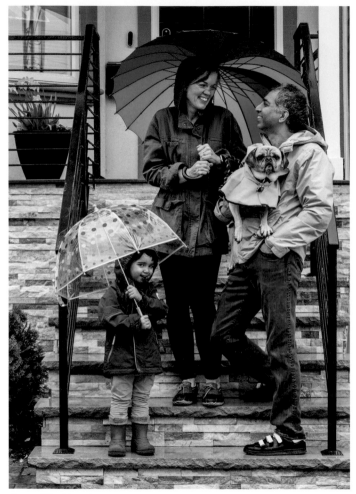

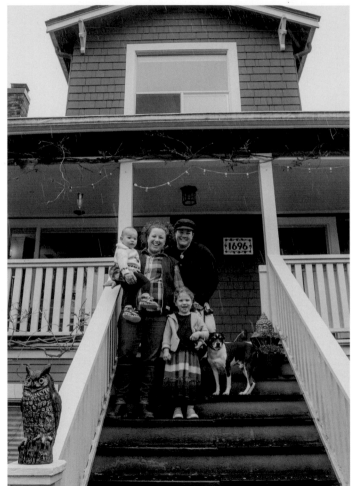

Jersey City, New Jersey Erica Schultz

Vancouver, British Columbia, Canada Laura-Lee Gerwing

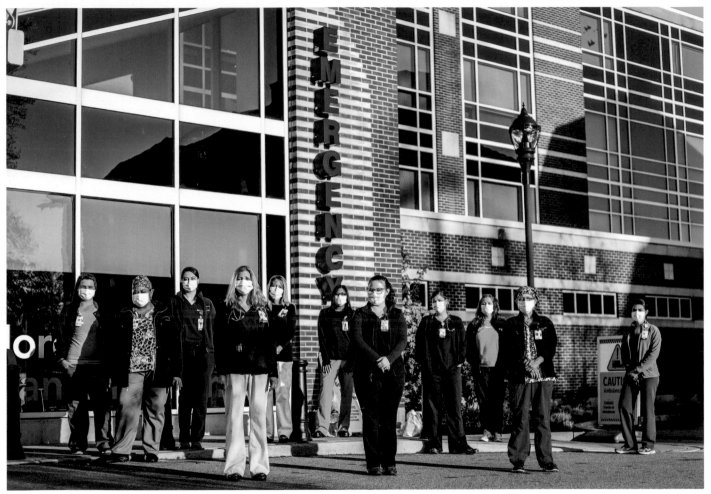

New Bedford, Massachusetts

Chelsey Puza

INDEX

Thank you to...

Our husbands and children, for your extreme patience, constant love and support, especially during the crazy early days of The Front Steps Project.

Rachel Metzger at West Margin Press for participating in The Front Steps Project in Alameda, California and thinking: This might make a good book!

Jen Newens at West Margin Press for agreeing and convincing us that, even if we were exhausted, we should publish a book that highlights all the GOOD that spreads thanks to The Front Steps Project.

Angie Zbornik at West Margin Press for teaching us all about marketing and selling a book, and for doing it on our behalf with the Ingram team.

Topher Cox, Caitrin Dunphy, and Kate King for stepping up to help make The Front Steps Project a massive success in Needham, Massachusetts.

Lily Weitzman for working all hours of the night to help us with our website, and to her team of Jacquelin Cooke, Michelle Heath, and Risa Kent for putting the early pieces of the puzzle together.

Sandy Robinson and the Needham Community Council for undeniably being the most deserving nonprofit for our efforts. Your tireless dedication to the residents of Needham is an inspiration and one of the many reasons we kept going.

Participating residents in Needham for your enthusiasm and support of The Front Steps Project, the Needham Community Council, and each other.

John Bulian of the Town of Needham Select Board for being accessible, cheering us on, and providing positive feedback and guidance as COVID guidelines evolved.

Lillian Soulia for being a number-one Front Steps co-pilot and Shirley Gordon (Gigi) for her savvy internet research.

Jen Bauer, Kathleen Bums, Ginger Bunn, Carter Carnegie, Jenna Donleavey, Eliza Fortenbaugh, Theresa Freeman, Jeff Janer, Jess Kadar, Scott Kirsner, Kirsten LaMotte, Katie Maxim, Tamra McCraw, Jules Pieri, Patti Richards, Brenda Salamone, and Amy Traverso for offering support, advice, and ideas as The Front Steps Project grew.

The team at Wrigley Media Group in Louisville, Kentucky: Forest Erickson, Mandy Daugherty and Zack Brewer.

Alyssa Kence for jumping through hoops to secure one of our favorite images, the staff at BID Needham, as they prepared for a surge in patients.

The reporters and producers who shined a light on The Front Steps Project in cities and towns across the country and globe. Your support helped the mission grow, which ultimately resulted in more funds raised for nonprofit organizations and local businesses.

Finally, thanks to all the photographers who voluntarily replicated The Front Steps Project with a philanthropic spirit and intention. Your talent and hard work are the heart of this project and none of this would be possible without you.

For the hundreds of photographers
who chose to **UNITE** their communities in a time of crisis,
the healthcare community for exemplifying true **COURAGE**,
and the local organizations that **SUPPORT** those in need.

Library of Congress Control Number: 2020941190
ISBN: 9781513265858 (paperback)
 9781513265865 (e-book)

Proudly distributed by Ingram Publisher Services

Printed in China
5 4 3 2 20 21 22 23 24

Published by West Margin Press

WEST
MARGIN
PRESS

WestMarginPress.com

WEST MARGIN PRESS
Publishing Director: Jennifer Newens
Marketing Manager: Angela Zbornik
Project Specialist: Gabrielle Maudiere
Editor: Olivia Ngai
Design & Production: Rachel Lopez Metzger

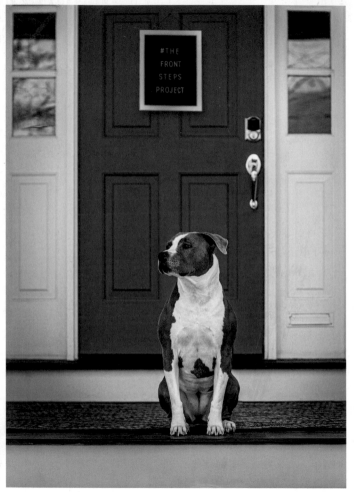

Needham, Massachusetts

Topher Cox

Thank you to the pets...
dogs,
cats,
turtles,
gerbils,
guinea pigs,
bunnies,
pigs,
horses,
and chickens
...who stepped up when their
owners needed their
UNCONDITIONAL LOVE.

Your smiles are beautiful!